THE
ART
OF
DAVID
EM

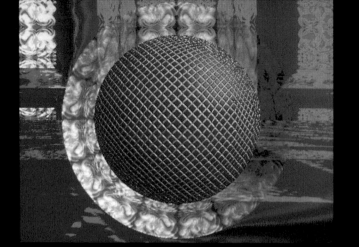

Texts by David A. Ross and David Em

THE
ART
OF
DAVID
EM

100 COMPUTER PAINTINGS

Harry N. Abrams, Inc., Publishers, New York

Editor: Charles Miers

Designer: Samuel N. Antupit

Library of Congress
Cataloging-in-Publication Data

Ross, David A., 1949—
The art of David Em :
100 computer paintings/
texts by David A. Ross
and David Em.
p. cm.
Bibliography: p. 124
ISBN 0—8109—1044—6
1. Em, David—Criticism and
interpretation.
2. Computer art—United States.
I. Em, David. II. Title.
N6537. E548R67 1988
759. 13—dc 19

Pictures selected and sequenced
by Roberta Spieckerman

A Times Mirror Company

Printed and bound in Japan

CONTENTS

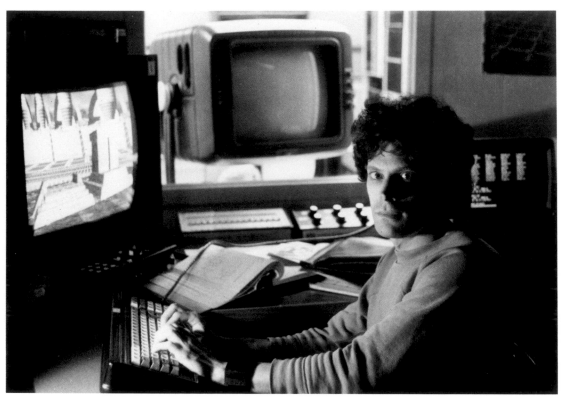

Fig. 1. David Em in his working environment at the California Institute of Technology's Jet Propulsion Laboratory. 1983. Photograph by James Seligman

DAVID EM

by David A. Ross

For ten years, David Em has used some of the world's most sophisticated computers and computer programs to create an imaginary universe of stunning beauty. His electronic creations have redefined the territory of technological art. In an extended series of remarkably original pictures, Em has developed a vocabulary that seems to combine ancient iconography with otherworldly landscapes. The resulting images evoke the feelings of surprise and excitement one develops upon meeting an absolute stranger who seems completely familiar. This is delightfully suspicious stuff.

Like the work of many innovative artists of his generation, Em uses a set of technologies that is alien to the established order of things. It seems, after all, quite reasonable for us to resist the further encroachment of computers and electromechanical forces into our besieged modern lives. But do we want artists to lead that resistance, or should they offer us new inducements for further exploration? It is inevitable that a discussion of Em's work must also include some consideration of these questions.

The recent history of art and technology engagements can be

read as a commentary on the modern industrial state and its potential for humanistic conduct. Popular culture, for instance, reflects a wide-ranging suspicion of new technologies. One only need scan the literature of science fiction to see the very real and present fears that commingle with our desires for an idealized future. Indeed, the twin nightmares of technofascism and global extinction are frequently portrayed as the ultimate by-products of increased technological sophistication. They stand as extreme examples of the loss of individually controlled destiny.

Even before the dawn of the cybernetic age and the nuclear era, rapid advances in technology were globally recognized as harbingers of the end of innocence. Visual artists throughout the twentieth century have recognized this paradox and therefore approached the onslaught of new technologies with a curious mixture of antipathy and celebration. The Russian Constructivists saw the advance of technology as the release of scientific forces that would liberate the impoverished masses in a grand concert of spiritual and material progress. Throughout the period of the Russian Revolution the questions that confronted artists (but that remained unanswered) were: can revolution give anything to art, and can art give anything to the revolution? In fact, the mediums available to these revolutionary artists was no more technologically advanced than that of their predecessors, but their belief in the powers of technology inspired them to reevaluate the ways in which artists could contribute to modern society. This led to a unity of purpose between the artist and the state as well as to the eradication of traditional distinctions between various kinds of art making.

The Italian Futurists held a more romantic (and, in a sense, reactionary) view of the changes technology promised. They embraced mechanization and the suprahuman mechanical sensibility of the twentieth-century city, ironically creating a sort of protofascist ideology. Marinetti's Futurist manifestos contained the seeds of the very real and pernicious fascism that flowered in the Nazi period. Although the Futurists also worked in mediums not yet radically changed by new technologies, they developed an iconography that celebrated the progress of science. Speed, continuous motion, unstoppable change—these were the elements that excited artists like Severini, Balla, and Boccioni. The development of powered flight had generated for them new visions of moving landscapes; similarly, the new machines of war—airplanes and long-distance artillery—led to profound changes in attitudes toward life and death. Killing became impersonal—the ultimate abstraction that remains with us in the nuclear age.

It was the artists of the German Bauhaus, however, who recognized that the new industrial tools could be used to create works that were not merely about an age but were of the age. Novel artistic processes were considered a logical extension of the century's technological and humanistic revolutions. At the Bauhaus, new technology was incorporated with traditional craft values to create a modern visual aesthetic for all fields of creative endeavor—from the ballet to urban design.

Thirty years later, during the period roughly synchronous with the emergence of Conceptual Art (the late 1960s through the mid-1970s), the rapid evolution of communications and information-processing technologies once again brought issues of art and technology into focus. On the one hand, artists were primarily interested in understanding the essential qualities of a work of art on a philosophical level; on the other hand, they were concerned with extending or changing the artist's role in the society by developing an aesthetic that incorporated the tools of electronic communications. The common denominator of these goals was their emphasis on the value of the human presence in increasingly automated, abstract, and artificial environments. The Conceptualists embraced the ghost in the machine.

Computer art evolved in the late 1950s, receiving its first recognition in the late 1960s in the work of the artists involved with organizations such as Experiments in Art and Technology (E.A.T.), USCO, Zero, and others. Following a period when artists explored "new" technologies with abandon (a period perhaps best characterized by the spectacular yet fascinating failure of the mammoth *Art and Technology* exhibition at the Los Angeles County Museum of Art in 1971), it became evident that to engage advanced technologies artists had to recognize the values that the Bauhaus had introduced into technologically inspired art: they needed to focus on the aesthetic manipulation of the new tools, no longer merely exploring the metaphoric residuals of these technologies and declaring the results Art. By 1971, the era of the modern artist as the conspicuous consumer of advanced technologies was over.

In the late 1960s and early 1970s, video, in its various forms, was the technological medium that emerged as the most concentrated focus of artistic attention. Much of the work revolved around the dominant video form—broadcast television—and centered on the production of an appropriate art vocabulary for this ubiquitous cultural force. This kind of video art, however, was a hybrid genre, situated somewhere between cinema and sculpture. It resulted in a dynamic and active new field, attracting artists who saw it as a way to escape the confines of the traditional art world and a new way to represent and enter a world dominated by mass communications.

During that same period, allied artists from diverse backgrounds, including painters, musicians, filmmakers, and even designers of computer hardware and software, recognized that the marriage of the computer and a video display monitor or cathode-ray tube (CRT) could be the basis for the creation of a purely electronic medium. Their new world would be the uncharted electronic universe that lay beneath and beyond the immediate scope of television.

It was the Korean-born video art pioneer Nam June Paik who first predicted the future for this medium in a discussion of the potential of the Paik-Abe video synthesizer, an early analog computer that was capable of distorting, reshaping, and recoloring (or colorizing) video images. In a score to his 1969 *Electronic Opera No. 2,* Paik noted that

the video synthesizer would:

enable us to shape the TV Screen canvas
as precisely as Leonardo
as freely as Picasso
as colorfully as Renoir
as profoundly as Mondrian
as violently as Pollock and
as lyrically as Jasper Johns

What Paik was predicting, in an era before electronic video image making merged with digital technology, seemed like a pipe dream. But like so much else connected to the revolutionary impact of the semiconductor and the microchip, this dream became a reality that quickly outstripped even the most outrageous technofantasies of the 1960s.

In the early 1970s, David Em was one young artist who shared that dream. Em arrived in San Francisco during the heyday of its psychedelic romance with electronic video synesthesia. He had received traditional training as a painter at the staid Pennsylvania Academy of the Fine Arts, and as early as 1971 he had produced some rather accomplished paintings. *Dyan* (fig. 2), for example, is an extremely well-painted picture in the somewhat conventional and provincial Abstract Expressionist style that was typical of Boston or London painters in the late 1950s. Em's academic work evolved from paintings with thickly applied brush strokes into sculptures produced with highly textured, painterly surfaces. For works such as *Tom-Tom* (fig. 3), Em had learned to use high-tech industrial fabrication equipment and (more significantly) to work and survive as an artist within the corporate environment of a factory. Em eventually left the Pennsylvania Academy as the result of a kind of frustration that was typical for the early 1970s. His professors were impressed with the sculptures he was fashioning out of polyvinyl chloride (PVC), polyethylene, and Rhoplex (the base of acrylic paint), but at the same time they were highly critical and deeply concerned that he was *too* willing to embrace technological means. Like many painters from conservative academic institutions, Em's teachers felt that it was impossible to make technological art. Technological art, they believed, lacked human presence, a critical flaw to those suspicious of the new tools.

Em's concerns had little to do with that "critical flaw." They had to do instead with a much more profound issue. Faced with a conundrum similar to that which concerned the late German critic Walter Benjamin in his consideration of whether or not photography might in fact be art, it became apparent to Em that the central question was not "is it art?" but whether the new technologies had so changed the world that the artist was forced to redefine the nature of art making itself.

It is not surprising, therefore, that Em decided to work in the field of electronic image making. Ironically, it was when he was working with the imprecise analog video synthesizers to produce pictures (such as his earliest electronically generated work, *Mira;* fig. 4) that he grew frustrated with both the late-hippy mentality of the Bay Area electronic video scene as well as the excruciatingly primitive nature of video technology. Although he had little desire to be an inventor, he found himself

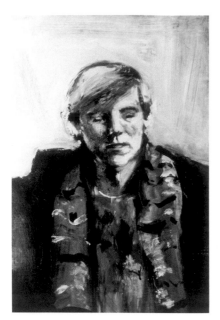

Fig. 2. **Dyan**. 1971.
Oil on board, 36×18″

Fig. 3. **Tom-Tom** (detail). 1972-73.
Mixed media (plastics), 7 × 15″

Fig. 4. **Mira**. 1974.
Analog video image

forced into that role in order to advance his profound interest in art and technology beyond the limited confines of video. Em worked with a group of engineers to devise a relatively sophisticated frame-buffer, an electronic device that stores and displays a single frame of video information (the contents of one full video screen). It functions as the video counterpart to a blank canvas upon which an electronic painting can be created from scratch.

By 1975, Em began to compose still-frame electronic images for the electronic canvas. He produced one of his first digital pictures, *Rasta* (fig. 5), on what he termed a "homemade pixel packer." This system (which would now be considered primitive) produced pictures with a distinctly blocky, "pixelated" look. Determined to retain the sense of touch he had as a painter and resisting the desire to evolve into a video/computer animator, Em insisted on both the primacy and the viability of composing electronic paintings. "I've always wanted the picture to remain still while the mind moves through it, rather than the opposite," Em stated in a recent conversation. "It isn't the notion of a still image that fascinates me, but rather the place the viewer occupies within the picture."

Shortly before producing *Rasta,* Em was invited to the then highly secretive research laboratories of the Xerox Corporation located just south of San Francisco in Palo Alto. There, he was allowed to work with their pioneering Superpaint system. Most current computer graphics "paint" programs still use the basic structure of this program. Superpaint provided the artist with a menu of colors, an infinite number of shaped "brushes" or mark-makers, and the ability to store the resultant images on a frame-buffer, so that later they could be combined with any other video-generated imagery or simply printed out on a laser Xerox copier. Em, like others invited to the lab, was astounded by the possibilities. Later in 1975, he left the Bay Area and moved to Los Angeles, where he received access to the Jet Propulsion Laboratory. With JPL's sophisticated computers, Em had the opportunity to become one of a small number of artists working around the world involved in rapidly developing the medium.

JPL, formally a part of the California Institute of Technology, since the end of World War II had been intricately involved with the growth of American space exploration, both developing the rocketry itself and conducting critical research in astrophysics and the space sciences. It had been reasoned that NASA would need enhanced graphics capabilities not only to process video imagery beamed back to Earth from deep space but also to develop graphic simulation models to help tell the story of space exploration to a world hungry for information.

Brought to JPL to develop programs that would help create computer graphic simulations of the historic flyby missions within the solar system, Dr. James F. Blinn was already known as one of the true geniuses in the complex world of graphics software development. It was into Blinn's laboratory that David Em found himself situated. A dream come true? Initially it might have seemed that way. In fact, if a judgment was to be made purely on the nature of the unique creative collaboration

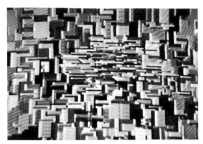

Fig. 5. **Rasta**. 1976
(Figs. 5–13 are computer generated)

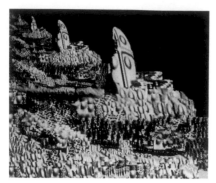

Fig. 6. **Aku**. (see plate 33)

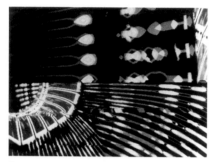

Fig. 7. **Navajo**. (see plate 3)

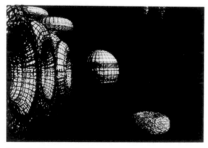

Fig. 8. **Donuts in Space**. 1978

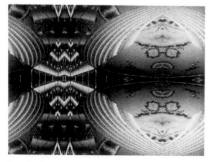

Fig. 9. **Suma**. (see plate 55)

that ensued, the situation might be considered unbelievable. Em had unlimited access to a personable creative genius and to the most sophisticated hardware available. Things did not, however, come quite so easily.

It took JPL several years to finally acquire and develop the hardware and software necessary to produce the kind of advanced pictures Em has become identified with. During the intervening time, countless bureaucratic nightmares kept Em's creative life in constant turmoil. It was 1978 before he created his first JPL works, and they radiate the raw energy that had been pent-up and finally released. The early group, including *Aku, Navajo,* and the whimsically titled *Donuts in Space* (figs. 6–8), were the first works to make purely creative use of the potential inherent in Blinn's elegant programs. These works constitute important examples of the first discernible phase of Em's work. In addition, they show off the nature of the medium in ways that immediately saw them used to illustrate the state of the art of computer graphics hardware and software.

Yet, understandably, the reality of working in an on-again/off-again fashion and trying to conform his creative activities to the available up-time on the JPL computer systems started to bother Em. Like his actor friends, he suffered the debilitating constraint of not being able to work when he felt a need to. While he longed for the painter's life, Em developed a performer's approach to working, preparing himself for nonstop, all-night sessions from which a new kind of art would emerge.

One thing that Em learned while still at school in Philadelphia was that his ability to survive the hostile environs of the corporate culture was an important component of his personality. It seemed to him that a primary factor limiting the growth of art produced with computers related directly to the isolated, discouraging, and generally alien high-tech corporate environment itself. But for some inexplicable reason Em has been able to glide through the acutely paranoid high-tech world relatively unscathed while remaining extremely productive.

One of the effects of his performance-like situation was a blurring of the notion of just where the work of art actually resided. Was the "finished" product the flickering electronic image itself, was it the photograph of the screen, or was the actual art his live interaction with the program and the hardware—the performance itself? Walter Benjamin, in his meditation on the idea of a work's "aura" in the "age of mechanical reproduction," would have been severely tested to designate the prime aesthetic event in relation to Em's work. Or has the extension of art into this nonmaterial, electronic sphere—unforeseen when Benjamin was writing in 1929—delivered the blow that erases the concept of that most genuine trait which in theory distinguishes the experience of art from the experience of other kinds of information? It was obvious to Em during this period that he was working with a medium that was still not fully developed.

It is conceivable that the works illustrated in this book will someday be "delivered" to an audience by direct electronic means. Perhaps the electronic forms that Em pulls from his mind are to be transmitted

directly into our minds by some (yet undeveloped) direct biological image interface? Regardless, it seems possible that our current reception of the images is provisional. The viewer wants to be inside these illusory worlds, to travel through their gravity-free electronic spaces.

Em's dreamspace began to crumble in late 1979. Machines broke, frustrations mounted, personal human relationships suffered, and he found himself in need of relief from the high-pressure world of JPL and the computer art scene. Em did not relish the idea of being typecast as a "computer artist." He disappeared into the jungles of Mexico for several months, and when he emerged his work and his attitudes had changed markedly.

Suma, a picture he made on the computer in 1980, was the first work to show the effects of his changed perspective (fig. 9). Gone was the sense of movement and action, the technical fireworks that give life to the earlier works. In their place, we find more restricted spaces and a more limited palette. Focusing on resonating formal relationships, Em's themes have shifted radically. We now see meditative, painterly spaces in his art—safe havens within electronic storms.

The space created by Em in the works of this period and in his more recent pictures has little to do with the space of science—fact or fiction—that characterized works like his tour-de-force, *Transjovian Pipeline* (fig. 10). The space in that picture, which emerged from the hyped-up, time-pressured condition of his picture-making approach at JPL, was an awesome space, whereas the space that we cohabit with the artist in works like *Approach* or *South Temple* is cold, clear, and silent—a contemplative void whose structure gives form to our disembodied experience of its essential emptiness (fig. 11 and plate 50). It is this refinement of his remarkable vision, which we see first indicated in his works of the early 1980s and can observe even more clearly in more recent pictures like *Terryl* and *Chin Li* (figs. 12 and 13), that serves as the key to Em's emergence as the leading artist using this new technology. Em has moved beyond crude experimentation with new vocabularies and has emerged as a mature artist with a distinct voice. His latest works, which glow with a soft light redolent of nineteenth-century landscape paintings, present an electronic space that, ironically, is as luxurious and comfortable as Matisse's fabled armchair for the weary businessman.

Do we need this computer art? Does it help us deal with our fear of the new? Does it empower us? I'm afraid these questions only serve as a frame and must remain unanswered. Like all important art, Em's work— for all its technological splendor and complexity—is economical. It is capable of transporting the viewer into a shared space within the artist's mind. This capability, which in fact transcends the content of any particular picture or the nature of this advanced picture-making technology, is finally what informs Em's work and forms the quite human matrix of intention that underlies his remarkable vision. His art defies a specific ideological reading, but like that of his Bauhaus predecessors it provides a powerful example of a new technology directed toward the essentially human longing for a language with which to explore the ineffable.

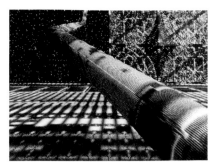
Fig. 10. **Transjovian Pipeline**. (see plate 16)

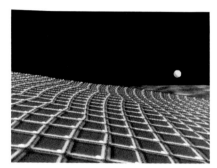
Fig. 11. **Approach**. (see plate 46)

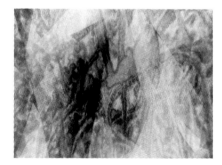
Fig. 12. **Terryl**. (see plate 44)

Fig. 13. **Chin Li**. (see plate 31)

A NOTE ABOUT MY WORK

by David Em

My father was a petroleum engineer and my mother was an artist. When I was a year and a half old, we went to South America, where we lived until I was twelve. We moved around a lot, living in Colombia, Venezuela, and Argentina. When I was fourteen, we moved to Connecticut. I was very unhappy in school, and I started drawing to make myself feel better. For the next three years, I drew constantly: portraits of friends, copies of paintings, nature studies. I attended evening life classes at the Silvermine Guild, read voraciously about art and artists, and on the weekends haunted the museums in New York City. In my senior year of high school I won a scholarship to art school, and I chose to attend the Pennsylvania Academy of the Fine Arts in Philadelphia, where I studied painting.

For my first two years in art school, I used oils to paint portraits and figures. Then I started working with plastic paints, and after a while I began making my own paints from scratch. The Rohm and Haas Corporation, which manufactures the plastic base from which most acrylic paints are made, is in Philadelphia, and one day I went by their headquarters to see if someone could answer some technical questions I had about the chemical composition of the paints. I met with two of their chemists, who it turned out were wrestling with some of the same problems, and they generously supplied me with information and materials that gave me much greater control over the physical properties of the medium.

As my artworks involved molding the plastic paints into highly textured three-dimensional surfaces, it dawned on me that what I was trying to do could be better accomplished with industrial fabrication equipment, and I began renting time on industrial plastics extruders in the area. By this point, the faculty at the academy didn't have a clue as to what I was doing, and I left after my third year of formal instruction. I moved to California, where I met the owner of a plastics factory who had an interest in the arts. He gave me an industrial extruder of my own to work with as well as access to his technical staff.

Over the next year I set up a collaborative relationship between myself, the management, and the technicians, in order to produce highly textured plastic sculptures on the fabrication machinery. I spent a lot of time lighting the pieces I was creating on the industrial machines, and after a while I began to think of them as three-dimensional canvases that I was composing with light instead of paint. The arrangement of highlights and shadows was the central focus of each piece.

One day I saw an old color TV someone was about to throw out. It was built into a huge old wooden cabinet and had a large round screen. It still worked, but the color characteristics of the screen had become extremely distorted with age, and the very dim television transmission signals it received produced forms that bore a striking resemblance to

the light and shadow arrangements I had been working on. I dragged the old tube back to my studio, where I discovered that by altering the hue, saturation, and brightness controls on the side of the set I could pull some really extraordinary color ranges out of the screen. For the next several weeks I spent hours on end staring at the screen and twiddling the knobs.

I soon wanted to gain more precise control over what the television screen was capable of displaying. I started asking around, and one evening I met Larry Templeton, an electronics engineer who had designed and produced a video image-processing system that could also electronically synthesize colors on a video screen. Larry was very interested in seeing the tools he had designed applied to the making of art, and I spent most of 1974 working with his system, creating colorful electronic paintings on television screens and recording the results on videotape. By the end of the year, however, it became clear that this system was not precise enough to explore the deeper ranges of the medium. I was able to determine overall hues and compose broad sections of the screen, but what I needed was the ability to control every dot.

I had heard through the grapevine that something along these lines was brewing at the Xerox Research PARC in Palo Alto. Alvy Ray Smith, a computer scientist and pioneer of computer imagery, was working there with a device called a frame buffer, which had been designed at Parc by Dick Shoup. Shoup's frame buffer offered total control over the hue, saturation, and brightness of every dot on a monitor. The frame buffer was controlled by a computer, and Alvy had written an interactive paint program for it called Superpaint. He and animator David Di Francisco were using Superpaint to create images for an animated videotape, and they invited me to see their system.

Early in the evening of January 6, 1975, I visited PARC for the first time. I had never been in a computer research lab before, so everything was new to me. Computers were everywhere. Alvy showed me how to run his paint program, which consisted of an electronic stylus that could create lushly colored and exotically shaped electronic brush strokes on a color computer screen. Moving the stylus across a digitizing tablet controlled the location and movement of the electronic brushes on the screen. Up to this point no one from a fine arts background had sat at the controls of the system. But the stylus and tablet setup were easy for me to adapt to because of my traditional painting background and my familiarity with video tools, and an hour later I had created my first computer image.

That night there was a discussion of what might be possible with the computer, and Alvy quickly programmed an electronic airbrush. After entering the program, he randomly swept it back and forth across the tablet, creating glowing white brush strokes on the black screen. There were no lights on in the room, so these large white forms made of pure light seemed to be suspended in the air. I knew I had found what I was looking for.

It was fortunate for me that my first encounter with high technol-

ogy had been so positive, because for the next two and a half years my experiences with computers were not. I quickly learned that making pictures with state-of-the-art computers required a lot more than simply learning to use the tools. Computer programs were delicate and fragile, as were many of the personalities who created them. Everything was in a state of development, and the machines tended to break down. Even when a picture had been created it was barely possible to document it. The dark specter of managerial bureaucracy also reared its ugly head, and a few weeks after I had discovered that computer image making existed as a medium, Xerox shut down its computer graphics lab, presumably because they could see no real world application for it. For the next nine months all I had to assure me that this electronic medium was not the product of an overactive imagination was an SX-70 Polaroid photograph of the first picture I had made, which David Di Francisco had shot off the computer's display screen for me.

Before Xerox shut down its graphics lab, I took Larry Templeton over to see it. Larry was pretty sure he could design a similar system. Since computer memory, and therefore resolution, was so expensive at that time, we decided to build a low-resolution system with an expandable memory. Days and nights were spent fabricating computer boards. Larry did the designing and I wirewrapped the computer chips to the boards.

Our excitement was contagious, and before long we were joined by another artist, Bill McMahon, and two engineers, Gabriel Normandy and George Ellis. We all contributed money, time, and love to the project, and soon our little system began to grow. Going into it, we had no idea it would take over a year and a half to build the machine, during which time we could not make a single image with it. The construction was extremely slow and tedious. I was constantly plagued by doubts as to whether it would ever work, and the frustration and constant delays ran counter to my experiences with other art forms. But when we were finished, we had a working frame buffer that could duplicate the capabilities of the Xerox system in low resolution.

I had become aware in the meantime that a few dozen computer scientists around the country were also devoting their energies to making pictures with computers. In the fall of 1975, Gabriel and I took a trip across America to visit every computer graphics installation we could find. Each system was a hybrid: no two were alike. Only a handful of people were involved, all of them very dedicated, inspiring, and open. They were just beginning to harness the vast potential of the medium.

Fred Parke, one of the scientists I visited, had a strange kludge of a system operating at Case Western Reserve. He suggested I look into the Jet Propulsion Laboratory when I got back to California to see if they were doing anything with computer images. When I passed through Los Angeles on my way back to San Francisco, I gave JPL a call. Although some scientists at JPL were heavily involved with the computer enhancement of photographs of outer space, they were not synthesizing computer images from scratch. However, a secretary there took an

interest in what I was doing and connected me with Bob Holzman, a member of the JPL technical staff who was looking for funding to set up a computer-imaging lab at JPL. Holzman turned out to have a deep interest in the fine arts. He thought it might be worthwhile for an artist to have access to a high-level computer graphics system, and he suggested we stay in touch. I called him a couple of months later, and over the phone he was ebullient: he had just gotten the lab funded. The next month I moved from the Bay Area to southern California.

The problems I had encountered building the homebrew graphics computer in San Francisco were greatly amplified at JPL. Simply getting the official passes for regular access to the computing facility took half a year. The computers were months late in being delivered, months late in being installed, and once they were up and running they ran programs that were of virtually no use to me. By then a year and a half had gone by.

During those eighteen months I had started spending my nights at a company called Information International Incorporated (I.I.I. or Triple-I), where two pioneers of computer filmmaking, Gary Demos and John Whitney, Jr., had set up a graphics system powerful enough to produce computer-generated animation for the television broadcasting and motion picture industries. Gary had programmed the I.I.I. computer to simulate three-dimensional objects on film, but the system's software was still under development, and it was quite convoluted and hard to control. I blundered forward slowly and eventually learned to make completely synthetic computer-generated objects with shaded surfaces move around in simulated three-dimensional space. After a year or so of hacking away, I finally made some pictures of a candy-colored cricket that could jump, fly, and flap its transparent wings.

In 1977, Eric Levy and Julian Gomez were hired as systems programmers at the JPL graphics lab, and the machines there finally began to respond to instructions. Jim Blinn, who had recently completed his now historic thesis on computer imagery, also came to JPL and implemented his ideas. Blinn's programs, which among other things could display objects with highly textured surfaces, represented a major redefinition of the field of computer imaging and made important advances in realistic simulation. One evening Jim gave me an overview of his programs, which I immediately saw were far more capable than any I had used up until that time. What I found most attractive was the fact that the various program modules (paint, lighting, object definition, and so forth) were integrated in such a way that they all communicated with each other, so that one program could interact with another. Later that night I used what I had learned to "paint" *Aku* (plate 33).

The middle to late 1970s were JPL's glory years. Photographs taken of Mars by the Viking Mars lander and of Jupiter and Saturn by the Voyager spacecraft flybys were beamed directly to JPL, where they were decoded and displayed to the world. As computers on board the spacecraft sent back the picture data, the features of the planets and their moons were scrolled onto computer screens and seen by human eyes for the first time. All of us watching felt as if we had been trans-

ported millions of miles from Earth. The wild cheers of the scientists filled the control rooms, and for months before and after a mission the air was alive with the astrophysicists' talk of trajectories, viewing angles, and space phenomena. Inevitably, a lot of this activity seeped into my imagery. While the scientists around me were using the computers to take snapshots of outer space, I was using them to design and document worlds of my own.

As the JPL graphics lab grew and developed over the next several years, it came to resemble an ascetic spaceship. Rooms were refrigerated to keep the computers happy, and due to the high reflectivity of the glass video screens, which creates color distortion, I tended to work in the dark. There were constant technical problems, with tape drives breaking down, disks crashing, and inexplicable memory burnouts. Sometimes people broke down too. Thinking back on it, it's amazing anything ever got done at all, yet it was an intensely productive period for everyone who was there, and although the rooms were very cold, my recollection of that time is very warm.

I enjoyed working with Jim Blinn's programs. Despite the fact that they had originally been written for scientific purposes, their capabilities were such that I was able to adapt them to my own very different purposes. They did more or less what I wanted and needed them to do, and I found them easy to use. As long as the hardware and software were both working, and I had access to the machines, I would make pictures with the computer for hours on end. The system's ability to manipulate vast amounts of picture information with great speed and flexibility allowed me to develop new working procedures. Ideas came up that would not have occurred to me otherwise, and the images began growing into and out of each other. Eventually I was able to use the computer intuitively, and as the tool became more and more transparent to me, I began to explore the unique qualities of the computer as an art medium, to see where it obeyed my commands and where it controlled my actions.

One of the things I liked best about the process was that by accessing different programs, I could work in areas that were formally very different. At times I would limit myself to the paint programs for days or even weeks. Then I might start working with two-dimensional transformations, which allowed me to study symmetry and geometric arrangements (plates 61 and 70). When a creative fork in the road appeared, I could save the current stage of the image in memory, explore one path, then come back to the stored image and explore the other, a process not possible in traditional painting. Images could be built up in layers, and elements of one could be combined with elements of another. A detail from one painting could become a texture wrapped around an object in another work, and the objects could be scaled to any size and viewed from any angle. I had always been interested in sculpture and architecture as well as painting, and now I was able to explore elements of these disciplines through the computer's keyboard, as well as investigating the properties of an entirely different medium.

Soon I started designing my own large, three-dimensional data bases, which simulated complete environments. I spent a lot of time in the early 1980s exploring these self-created worlds. Despite the fact that I had had to painstakingly define every bit of information in the hundreds of files they were composed of, they were full of strange and wonderful surprises. *Subter 4* (plate 73), *Gabriel* (plate 74), and *Adonde 2* (plate 72) were all part of a large data base that I devoted a lot of time wandering around in during that period. Most of the people in the field at that time were obsessed with animating their computer pictures, and for a while I was too. But gradually I found that what really interested me was creating paintings with electronic light. I also still took programs that had been developed for scientific purposes and adapted them to my own artistic purposes. *Ragnarok* (plate 59) and *Aftermath* (plate 60) were made in part by using a program that had originally been written to simulate the rings of Saturn. The twists in *Twist 1* (plate 41) I accomplished by using a program that had originally been written to simulate an expanding galaxy. Accidents also played a role in my image making. Bad bits would appear at random, usually at the worst possible times, but sometimes they contributed something unusual to the look of an image. The wavy grid patterns in *Where 3* (plate 45) and *Approach* (plate 46) were due to program errors, but these glitches are an important part of what makes the pictures work. When some of these bugs were ironed out later, the new pictures weren't nearly as interesting, and so I had to mix occasional random numbers into the brew to reintroduce an element of unexpected chance.

As the medium develops, new ways of displaying the picture data develop along with it. *Caribou 1* (plate 40) and *Caribou 2* (plate 87) started out as the same picture but were photographed seven years apart, using different display and film recording systems. They amount to different states of the same image. At one time it seemed that the digital domain was the ultimate archival medium because everything is stored in the computer memory as numbers. But it turns out that it is not a simple task to reconstruct the numbers in a manner that accurately reflects the artist's original vision. Since computer display screens can rarely be matched exactly and are subject to such things as color drift, phosphor decay, and vagaries of the nondigital real world, computer-generated art remains an extremely ephemeral art form unless and until the artist transfers the image from the computer onto some physical medium or the exact studio conditions in which the original image was created are reproduced in an exhibition setting. The whole problem of accurately reproducing the images became a consuming issue for me. Because I had been working exclusively with electronic light, I had ignored the properties of real light. In 1982, I therefore began to examine and redefine my assumptions and ideas about optics and color perception.

In June 1982, I made a painting in oils called *Salvador* (plate 85). It was the first time in over eight years that I had concentrated on the effects of natural light and it occurred to me how similar my pursuit of

the properties of electronic light was to the Impressionists' studies of natural light but how different our circumstances were. Where Monet painted sunlit poplars by the riversides, I had traded in the direct observation of nature for a pitch black computer room with radiation pouring into my eyeballs. Painting from real light for the first time in years refreshed me, and when I got back to the machines I began to work in more painterly directions (plate 91). Indeed, working with materials on physical surfaces on paintings like *-/* (plate 32) and *Invierno* (plate 82) felt so good that in the summer of 1983 I stopped working with computers for a year.

In March 1985, I went back to the keyboard. The system had matured a bit in my absence, and my ideas were different from what they had been before. For years I had been taking my cues from high technology, from which I had learned much about myself. Wandering the mesas and studying rocks and clouds in northern New Mexico (where my studio was) had now changed my sources and references drastically. When I returned to the computer, a very different integration of medium and inspiration occurred from what had taken place before, which became articulated in pictures like *Sunrise* (plate 90) and *Teec Nos Pos* (plate 99).

While I was away from the high-tech lab, I became extremely conscious of how much the tools we use determine the physical and social environments we live and work in, and how much these factors influence our perceptions and ideas. How tedious and time consuming it must have been for Rembrandt's studio assistants to grind up a tiny quantity of paint for the master's daily work, compared to more recent times when an artist like Jackson Pollock, alone in his studio, could take advantage of drums of commercially produced paints to develop new creative directions. Now, by eliminating paint entirely from the initial creative act, the computer is pushing the envelope of imaging a little further, opening the way to a vast new and unpredictable visual territory.

How physically and spiritually removed sitting in front of a computer terminal is from the experience of a prehistoric cave painter making a red handprint on a cave wall. Perhaps if the prehistoric painter were presented with Velázquez's paint box and brushes it would take him a little while to grasp what had been delivered into his hands. And perhaps it will take us a little while to appreciate that the computer, which has so suddenly appeared in our midst, is likewise a wonderful and mysterious gift.

THE PLATES

All images are computer generated unless otherwise indicated. (See Technical Note, page 106.)

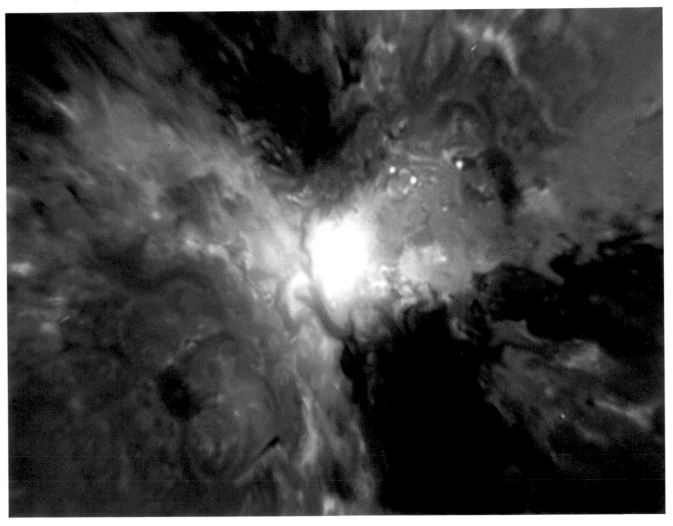

1. MAR. 1985

3. NAVAJO. 1978

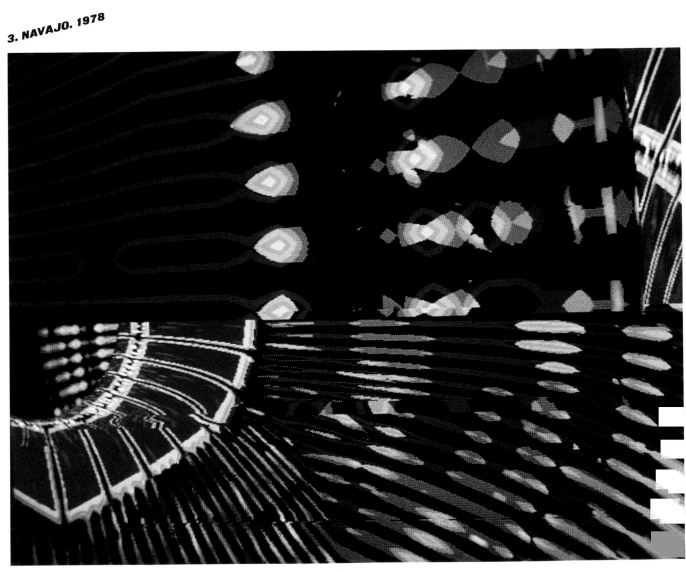

4. HILLS. 1985

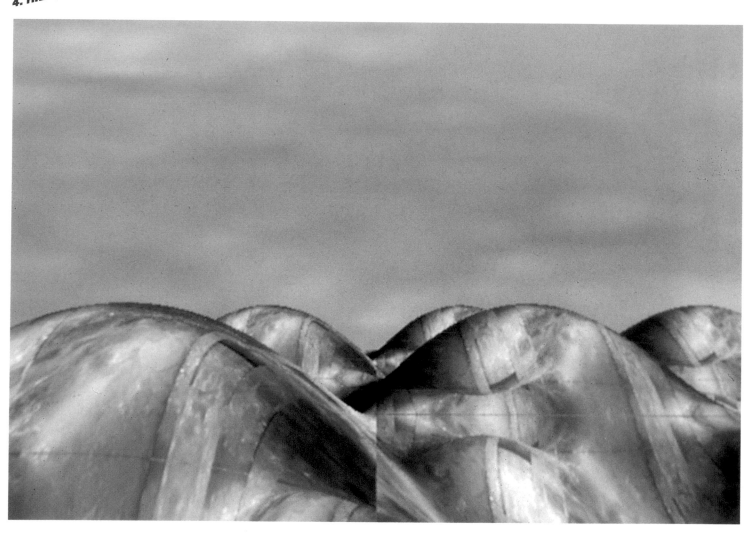

5. MIX 3. 1979

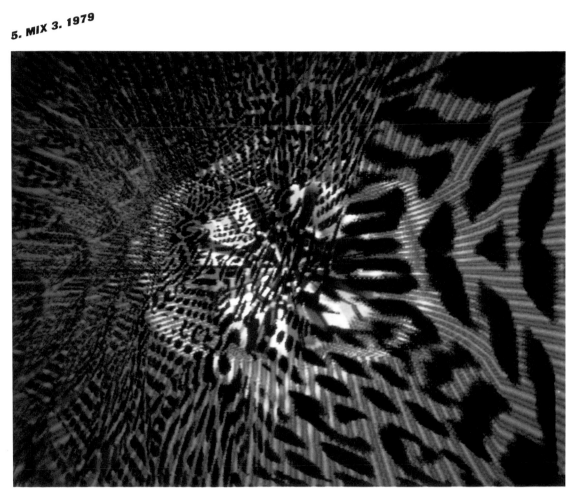

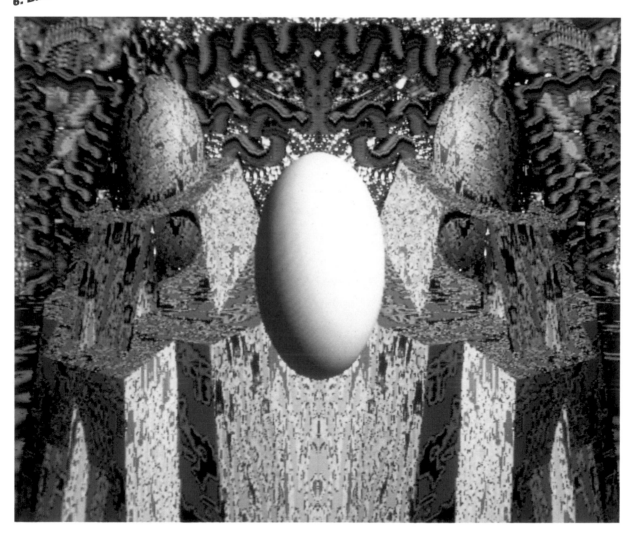

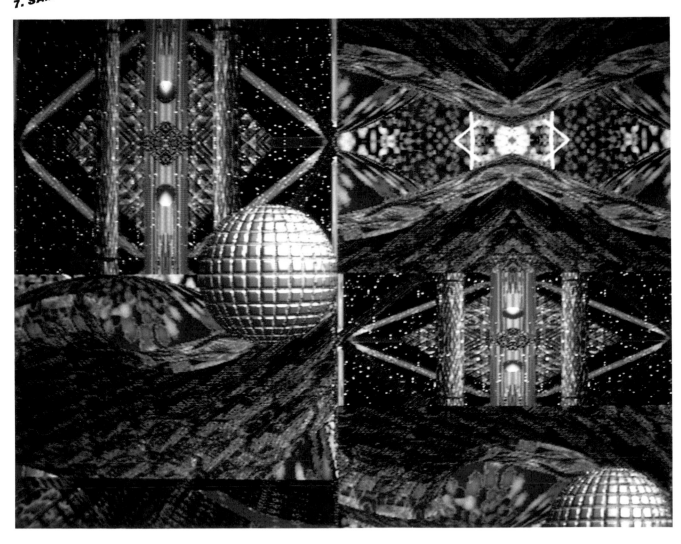

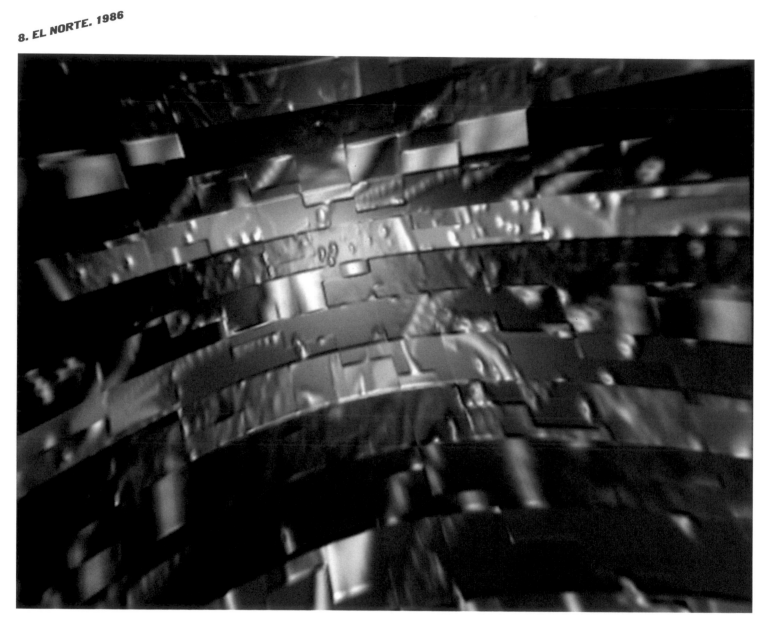

9. HATTIE ROSE. 1979

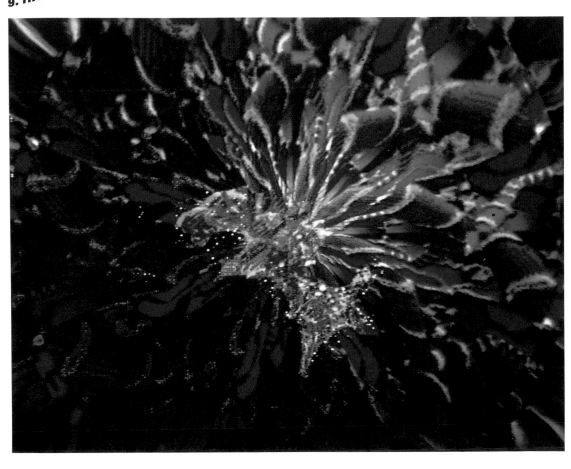

9. HATTIE ROSE. 1979

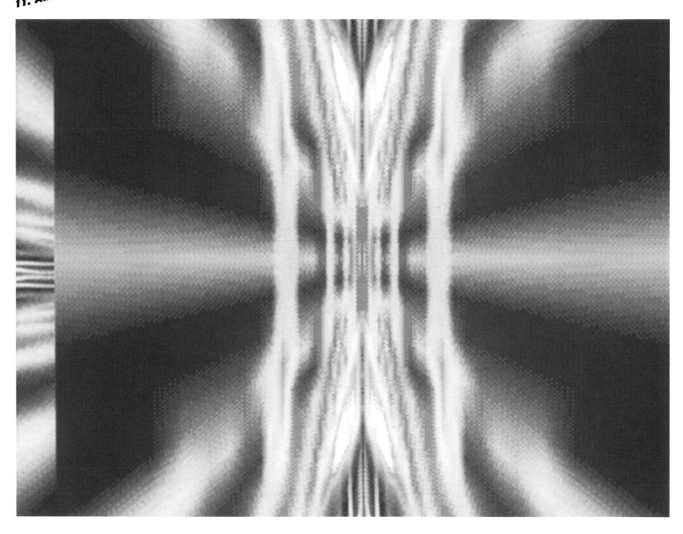

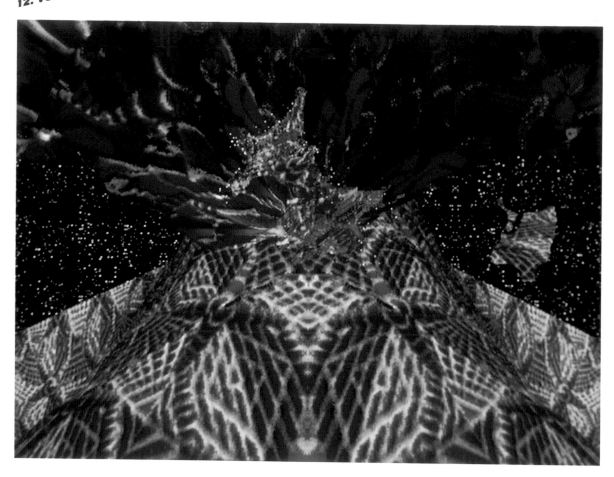

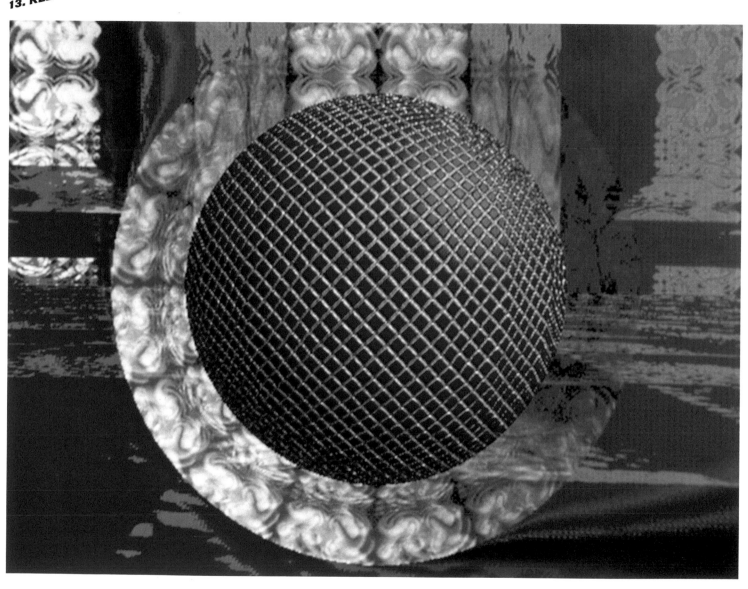

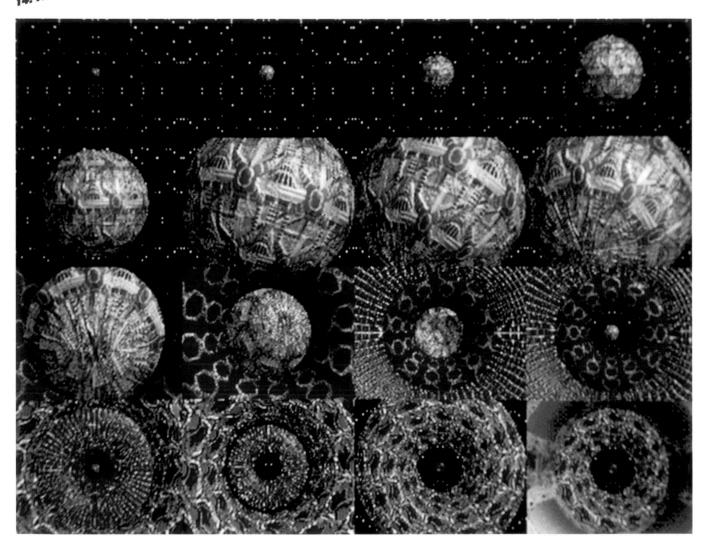

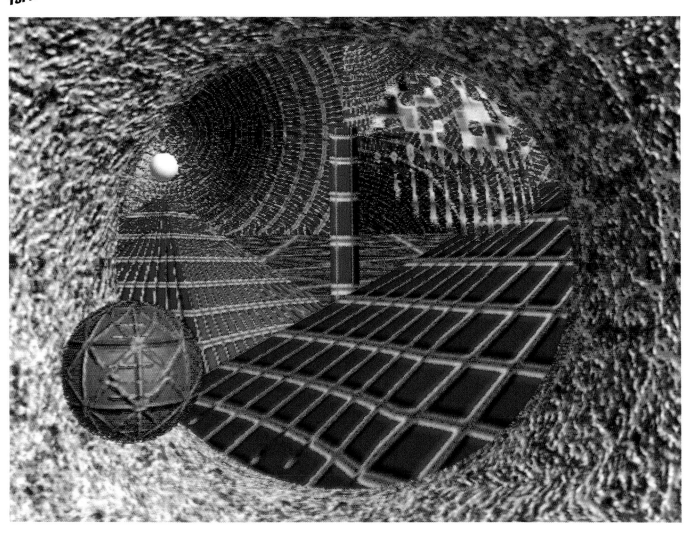

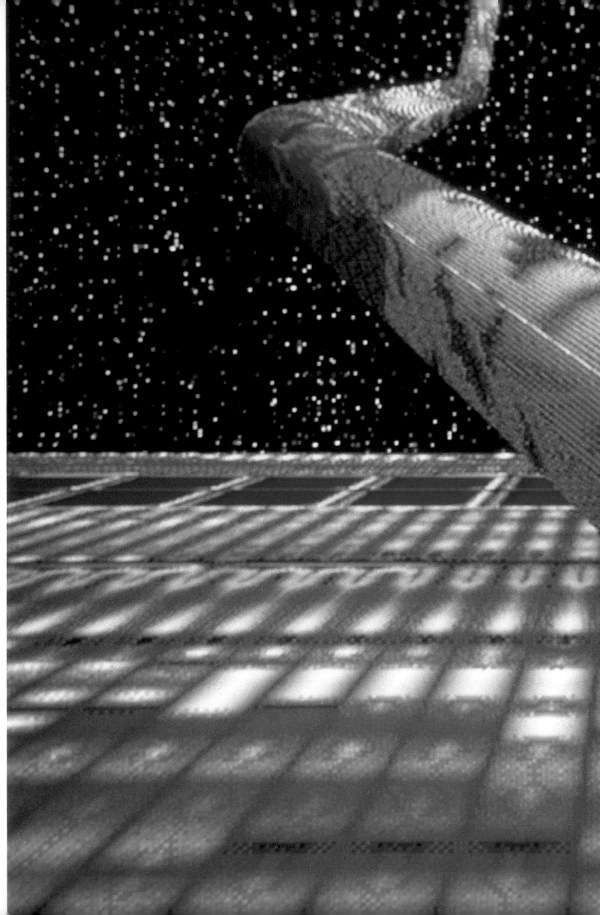

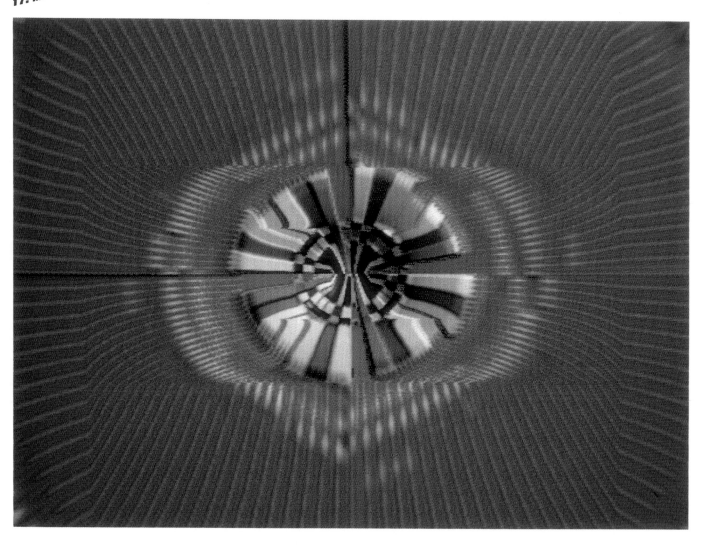

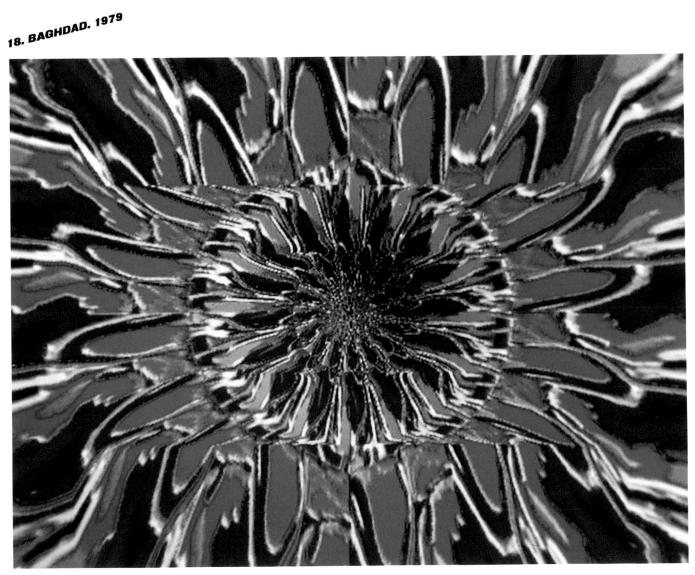

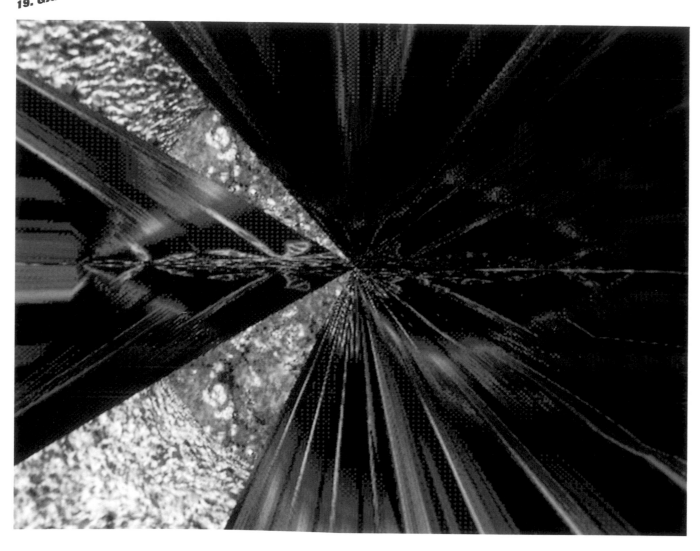

20. APAINT 3. 1987

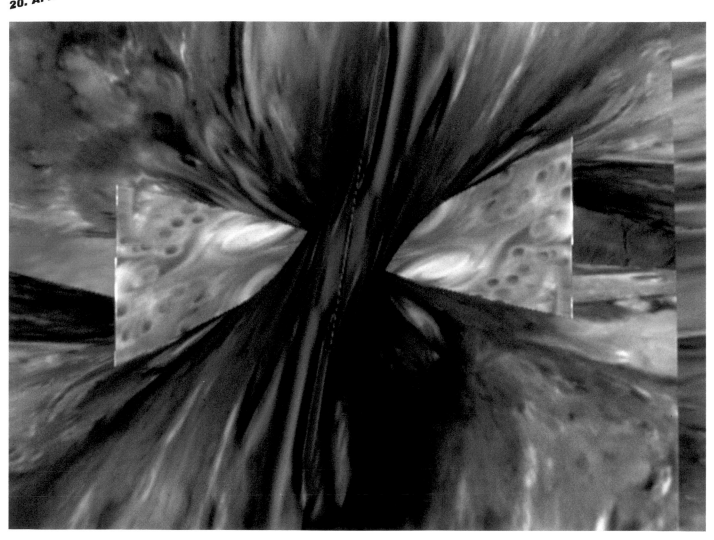

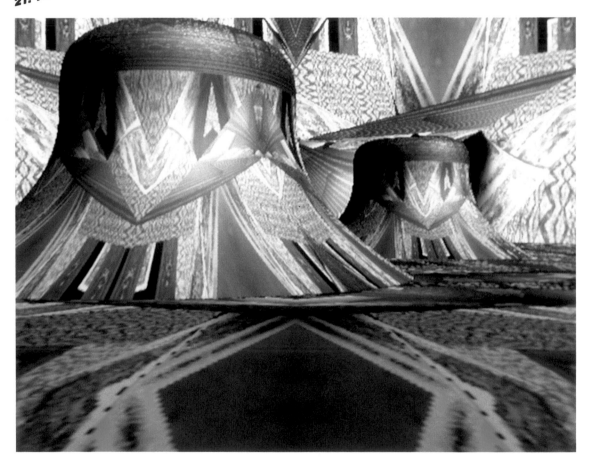

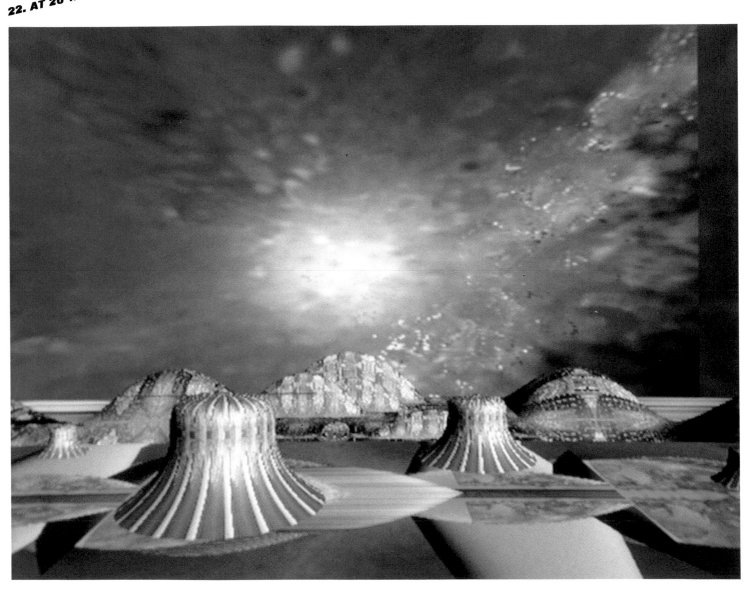

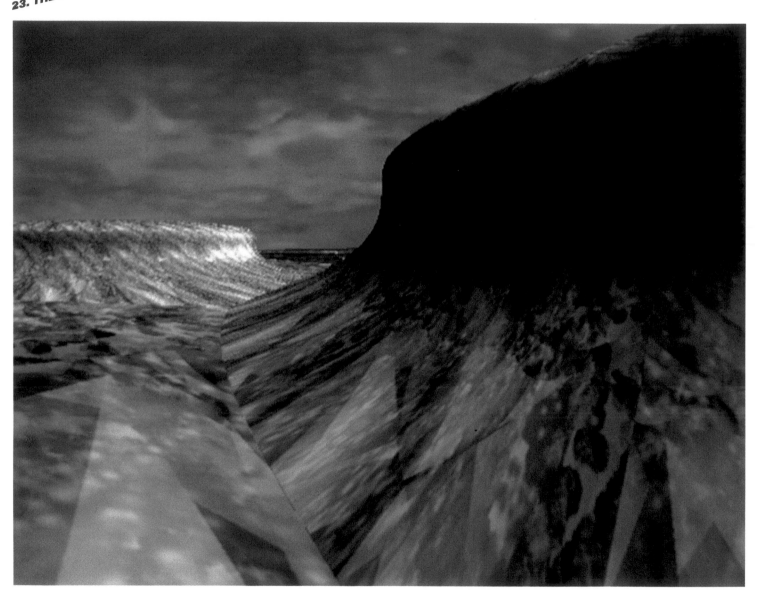

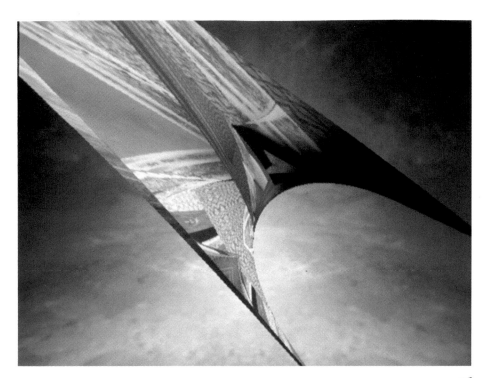

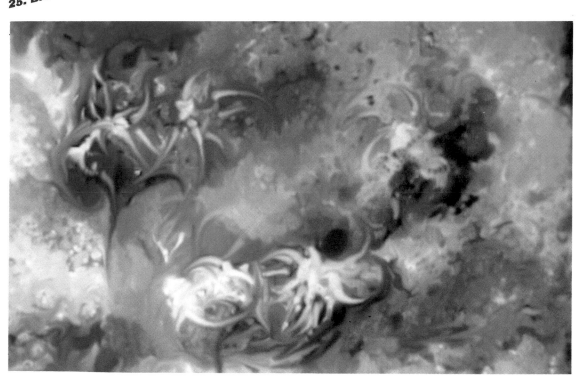

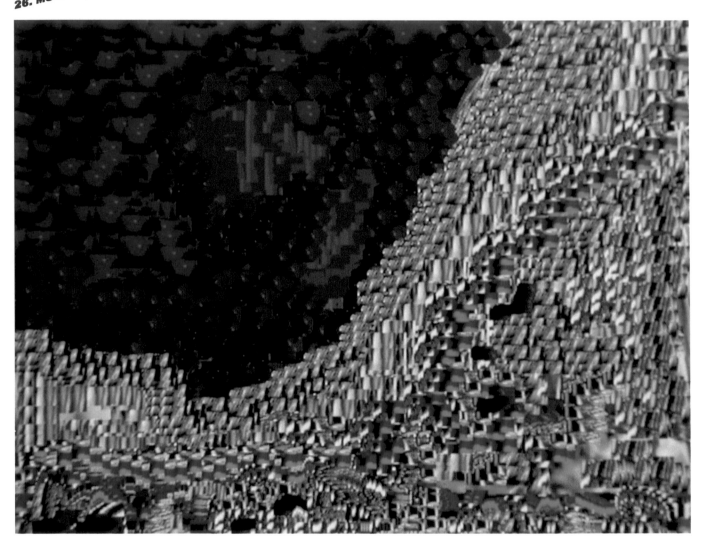

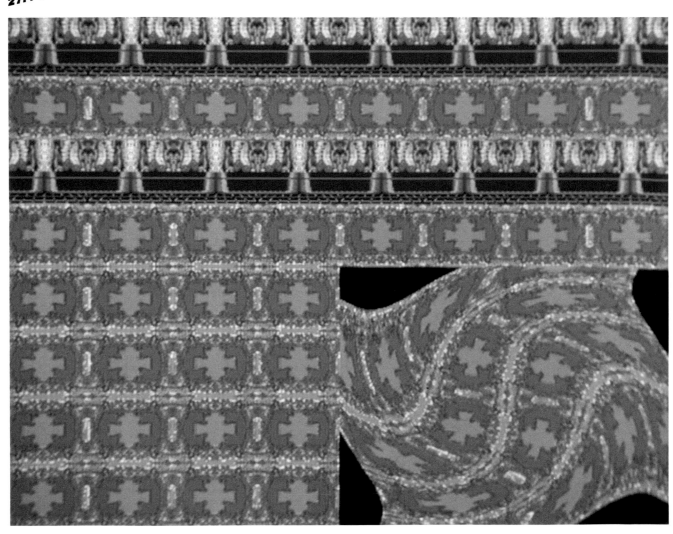

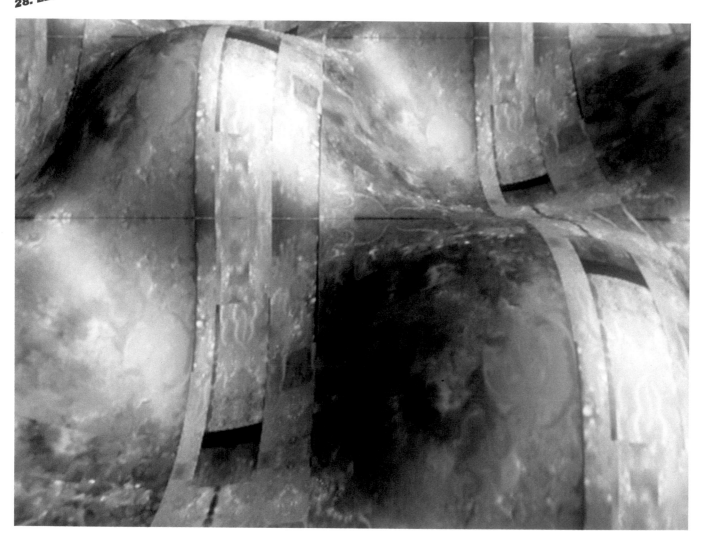

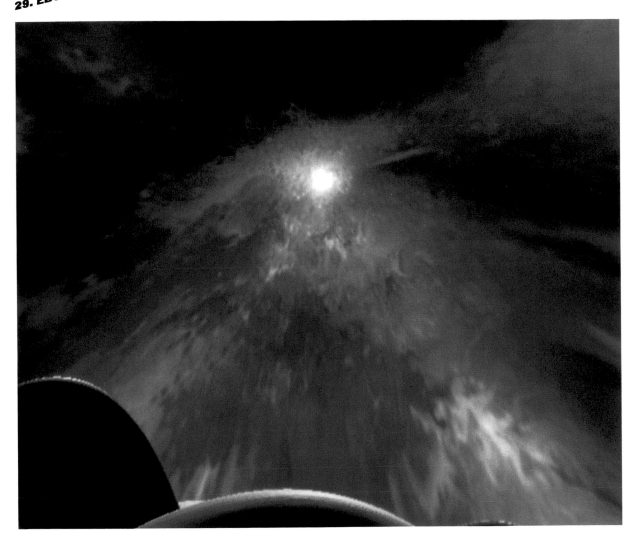

30. JOE AND NARTUHI. 1985

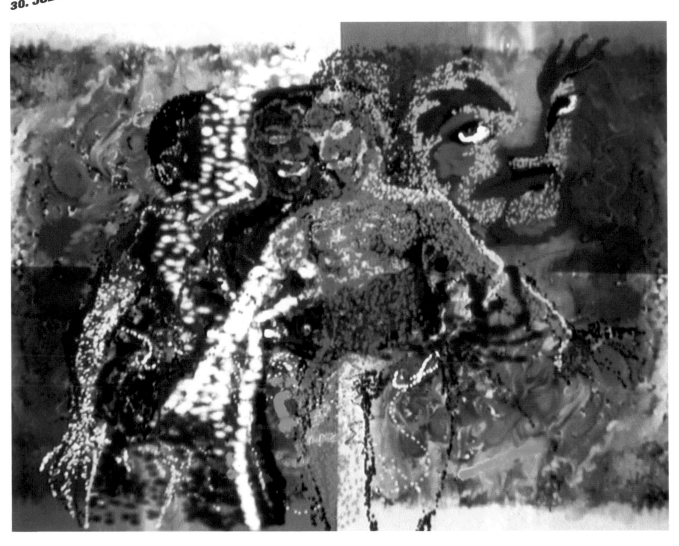

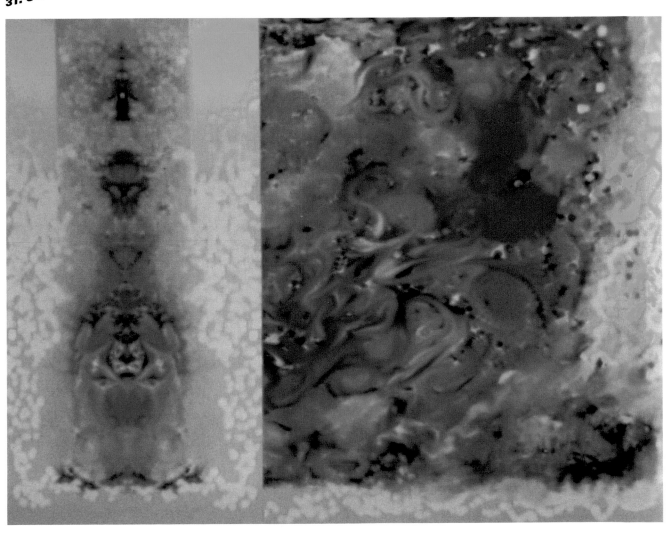

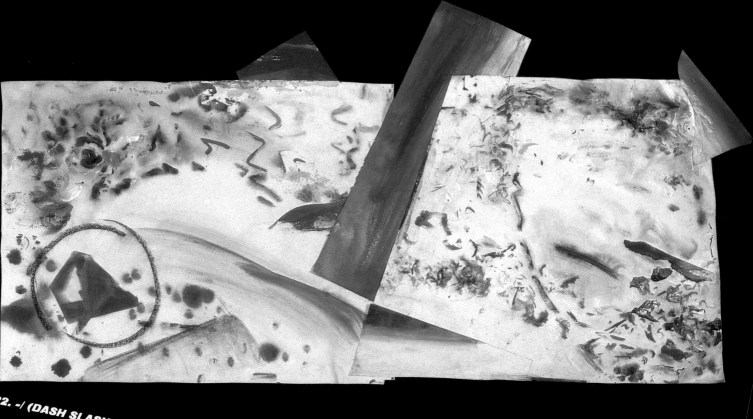

72. -/ (DASH SLASH). 1983. Acrylic on paper, 22 × 45"

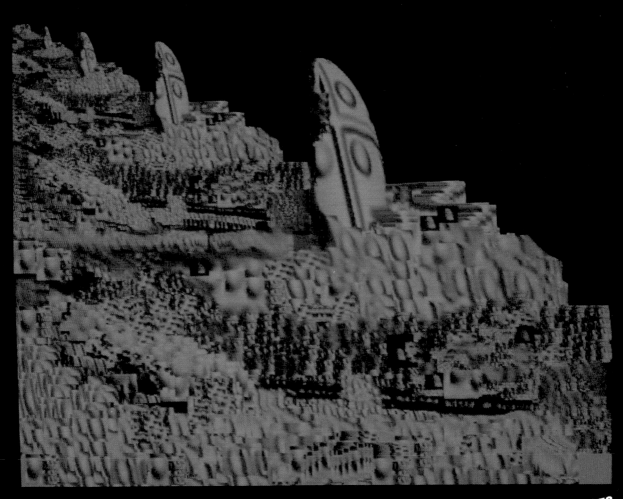

33. AKU. 1978

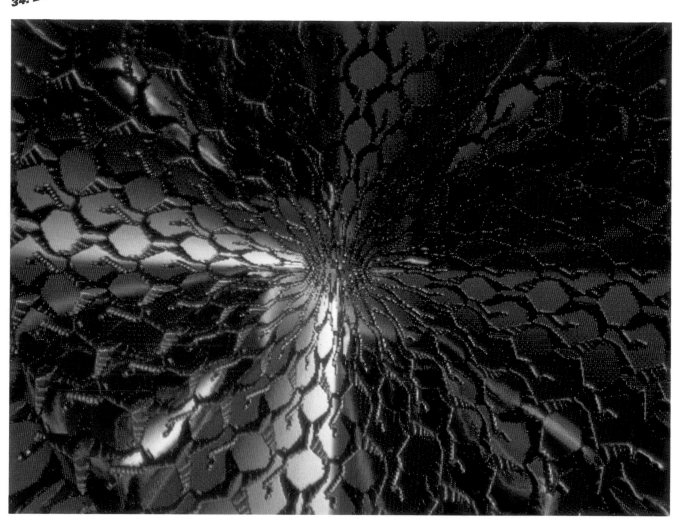

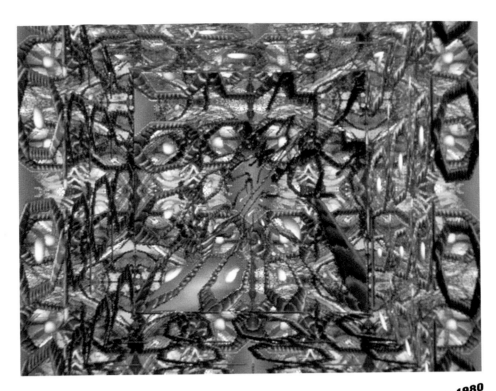

35. KAOS. 1980

36. PATRICIA. 1980

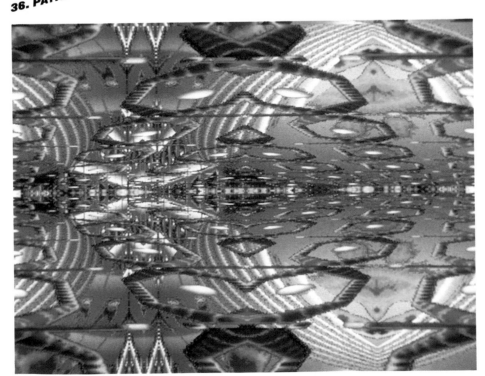

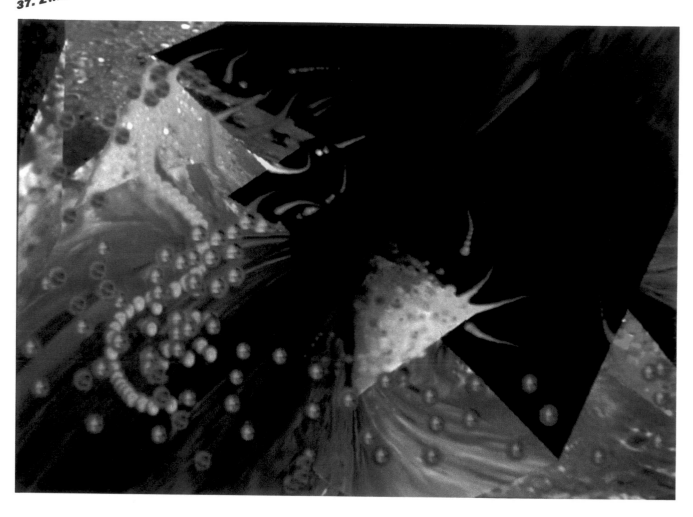

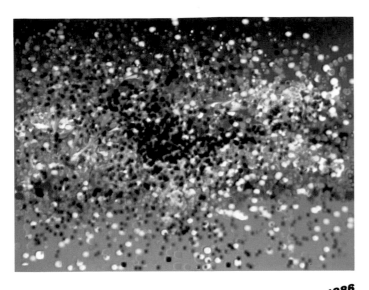

38. PARTY PARTY PARTY. 1986

40. CARIBOU 1. 1979

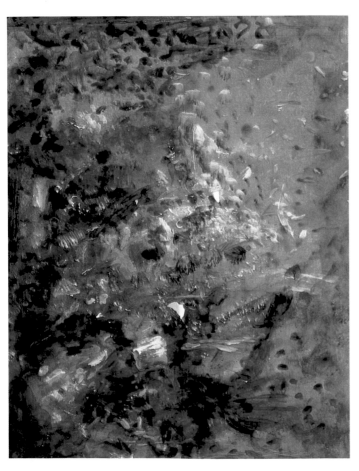

39. EL SALTO. 1985. Acrylic on paper, 24 × 19″

57

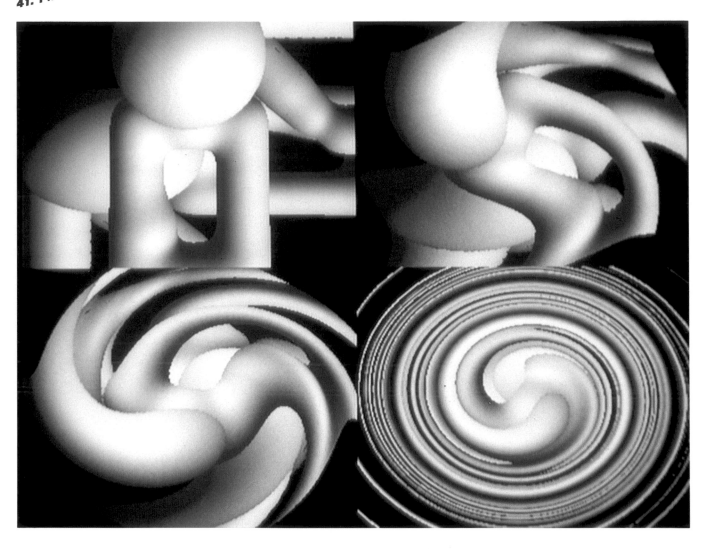

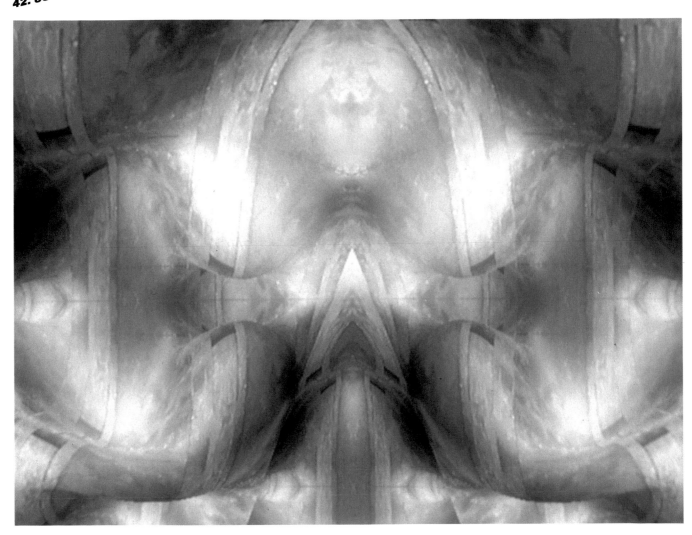

43. HEAVEN. 1986

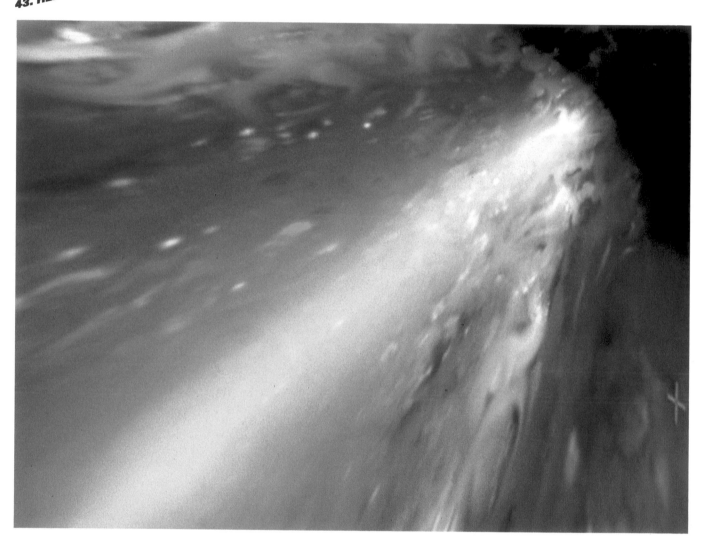

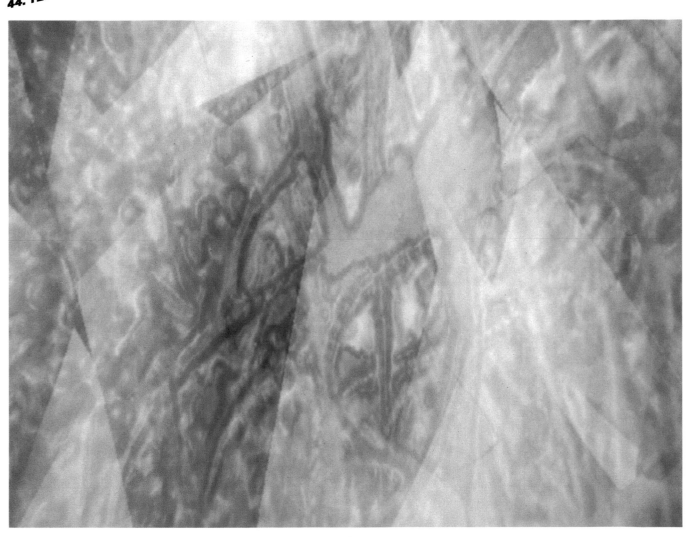

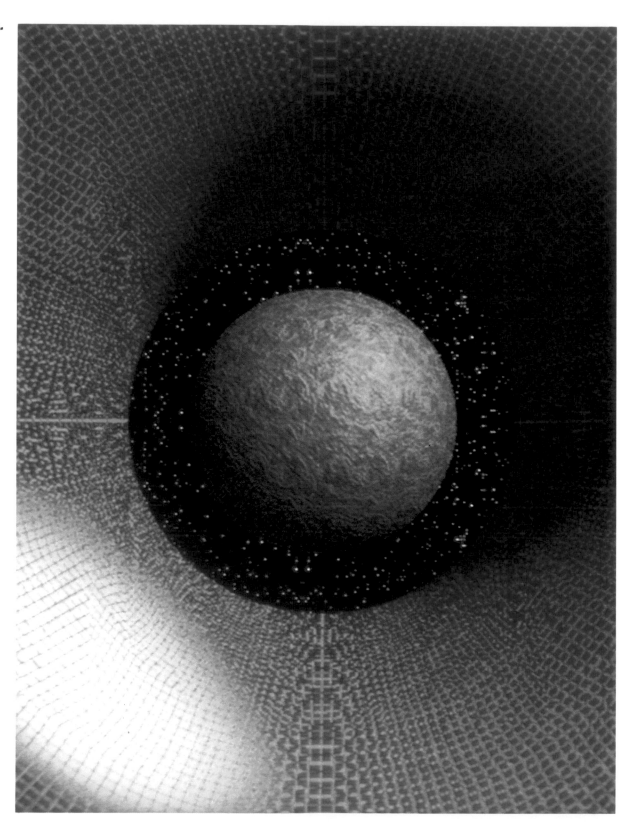

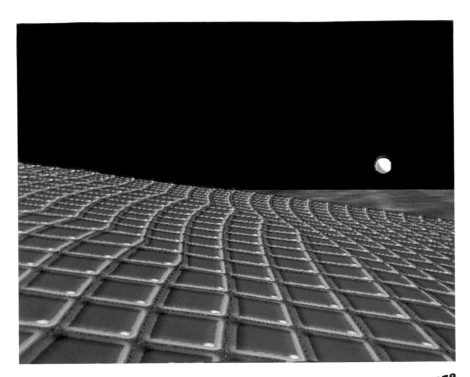

46. APPROACH, 1979

47. DRESDEN, 1979

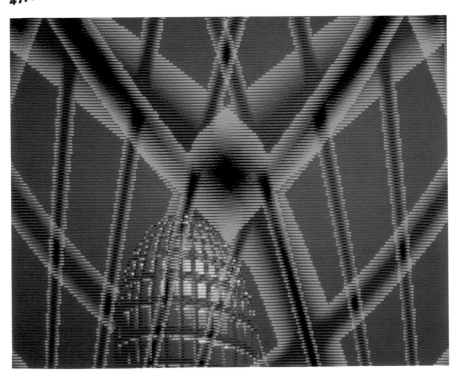

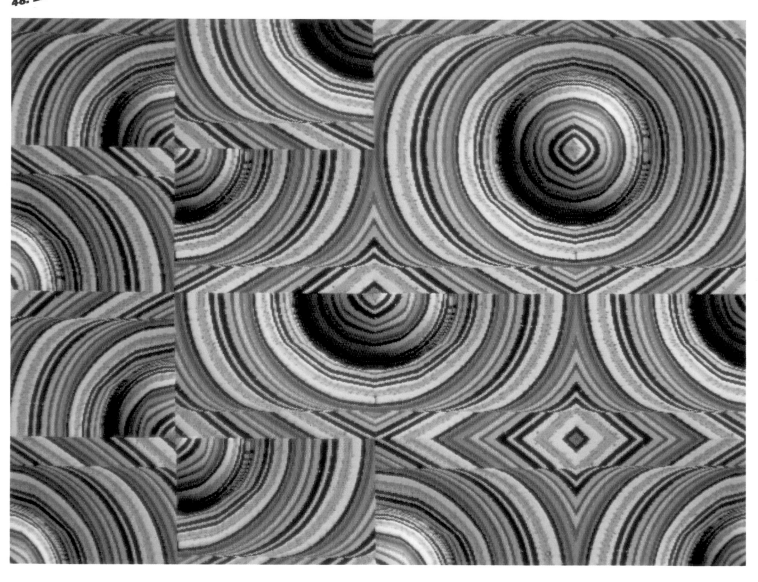

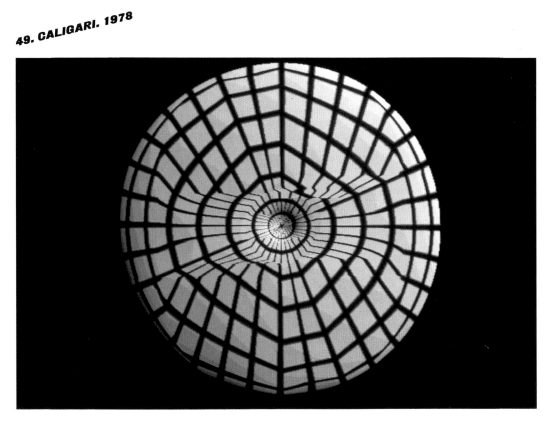

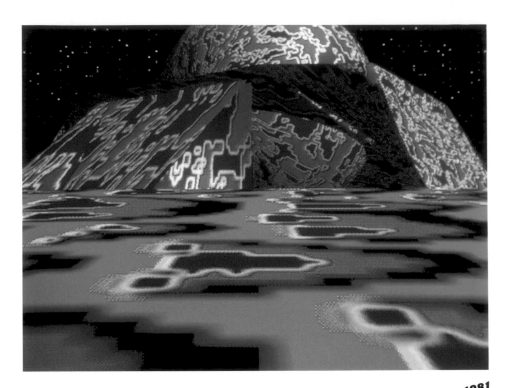

51. KOLUMN. 1982

50. SOUTH TEMPLE. 1981

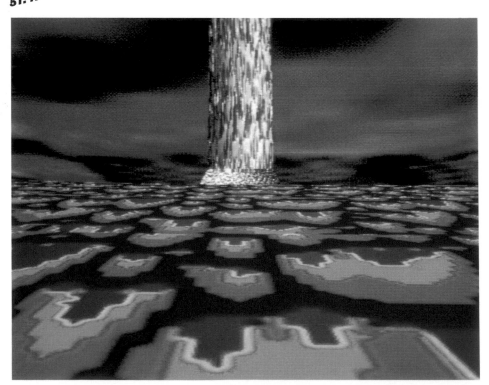

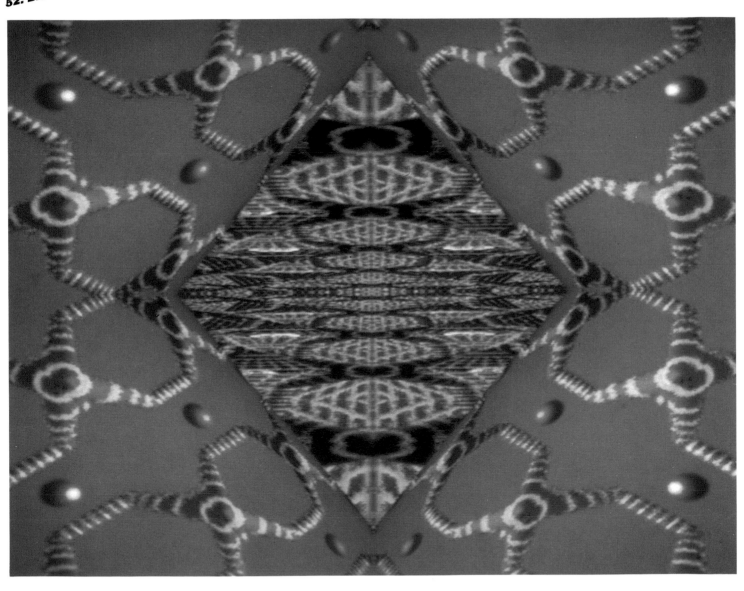

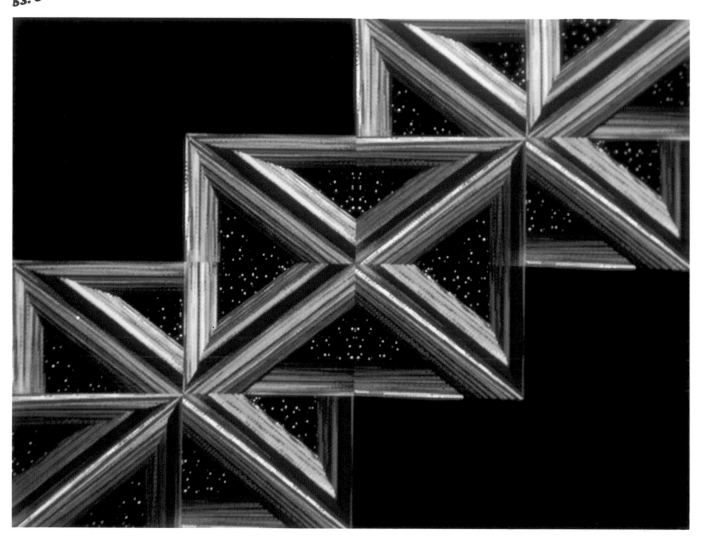

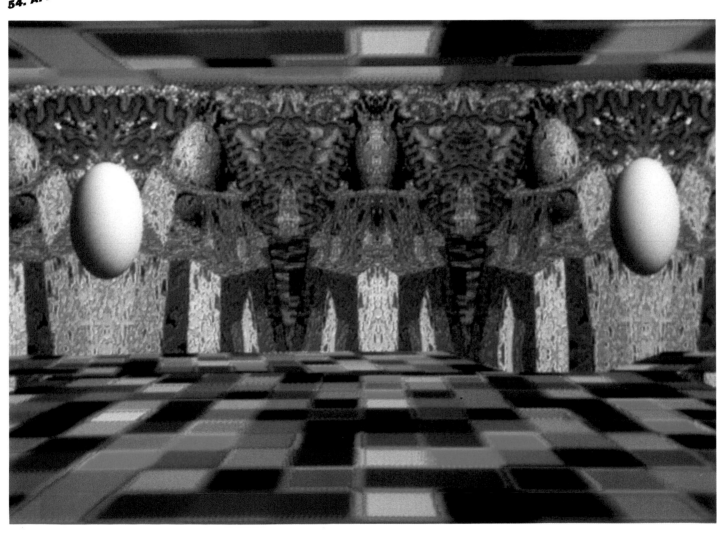

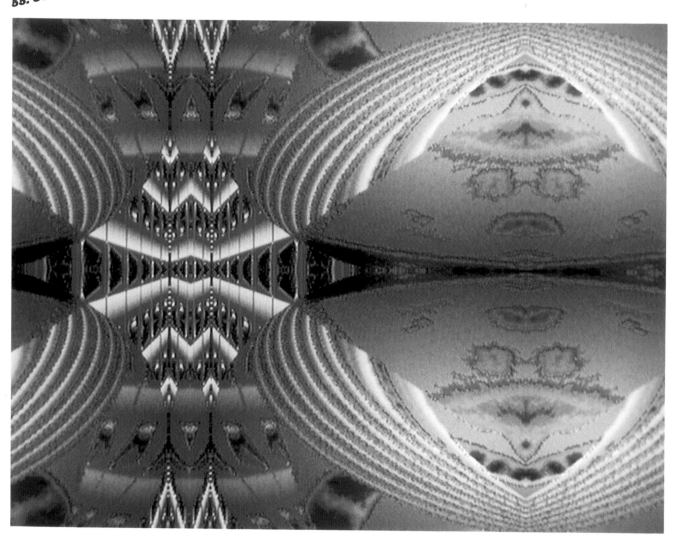

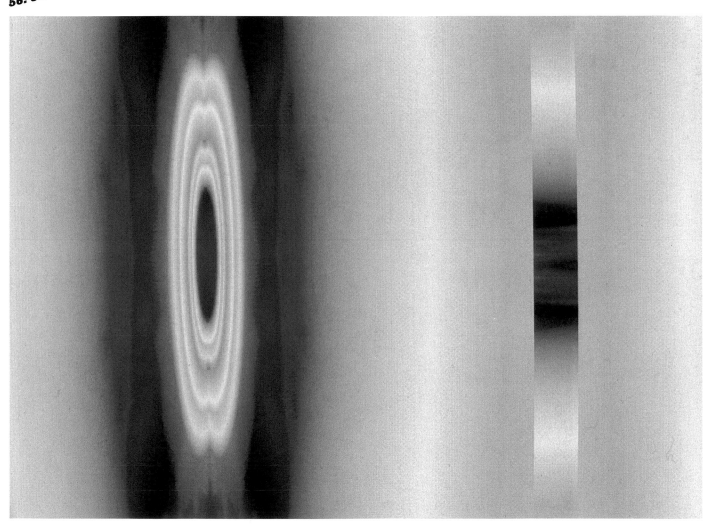

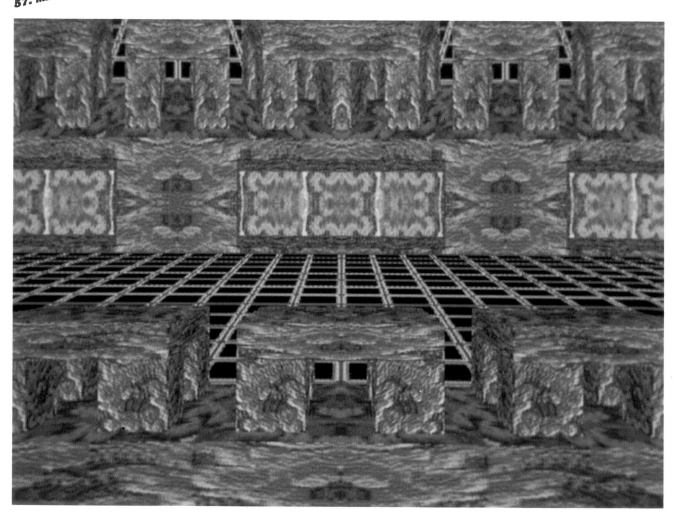

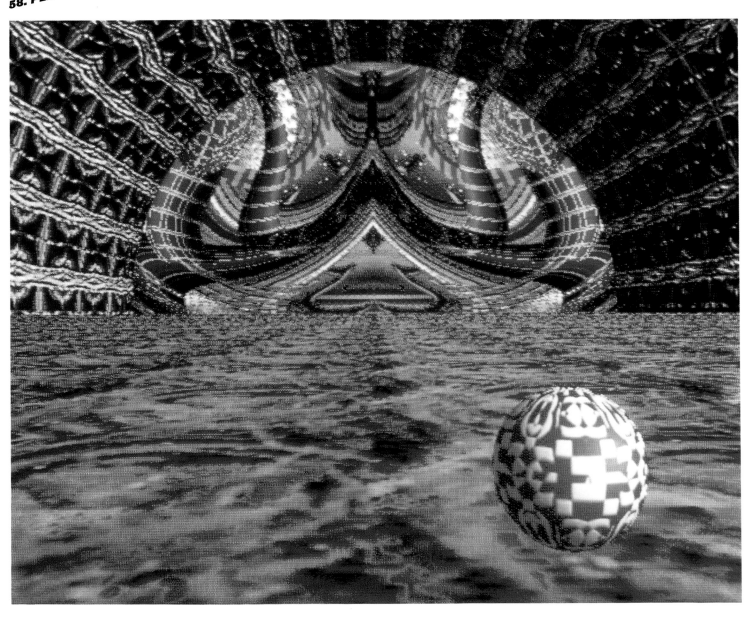

59. RAGNAROK. 1980

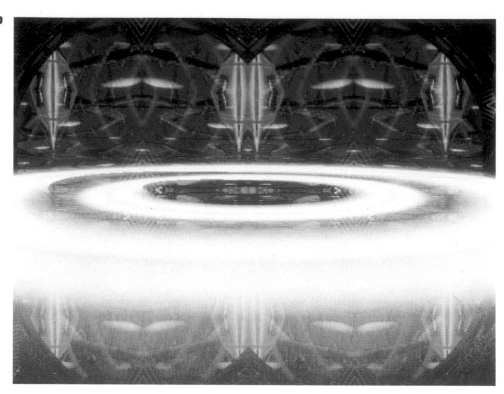

60. AFTERMATH. 1980

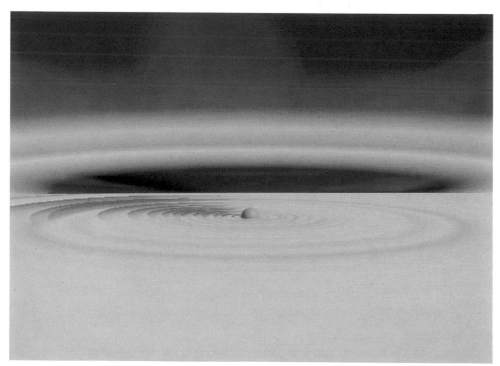

61. CHANG. 1979

63. GALAXY. 1974.
Mixed media on sheetrock, 13×13"

62. KIRBY 1. 1979

64. GUSTAF. 1985

65. BLANC. 1985. Oil on canvas, 12 × 16"

67. SPERM. 1980

69. CENTER 4B. 1979

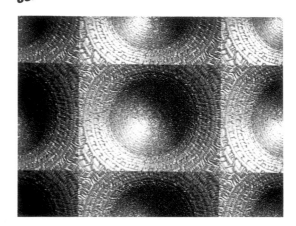

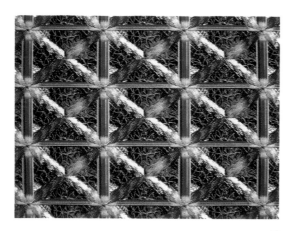

68. JELLY. 1979

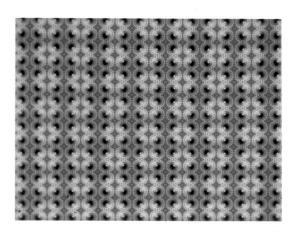

70. PERZIA. 1980

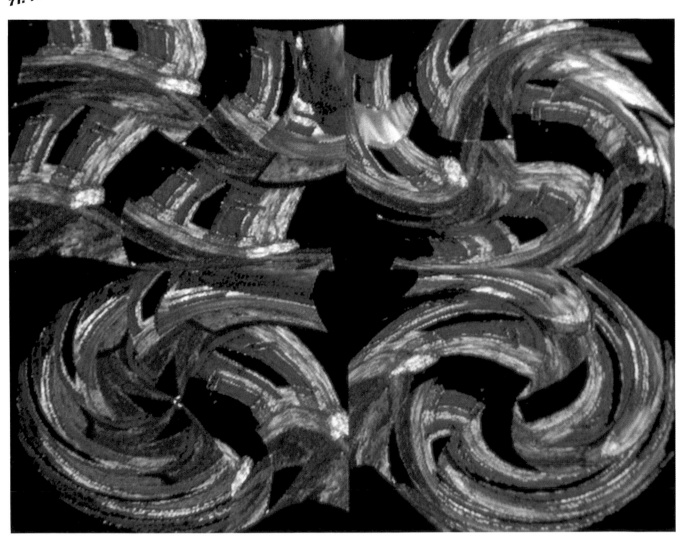

72. ADONDE 2. 1981

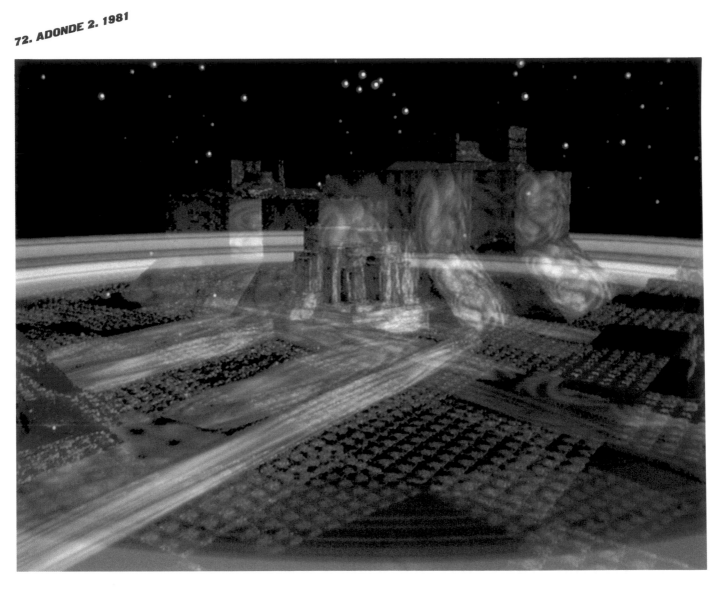

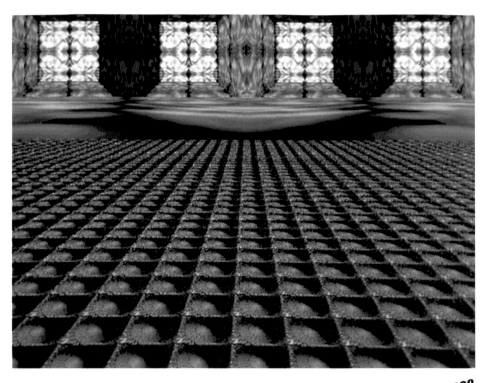

73. SUBTER 4. 1980

74. GABRIEL. 1980

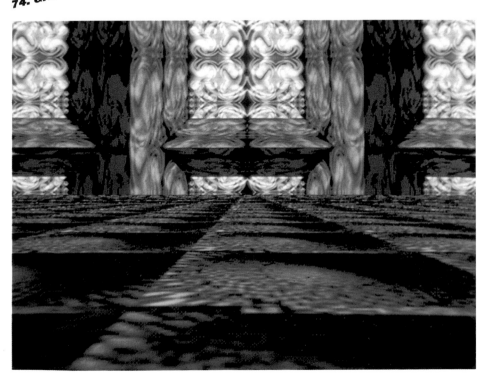

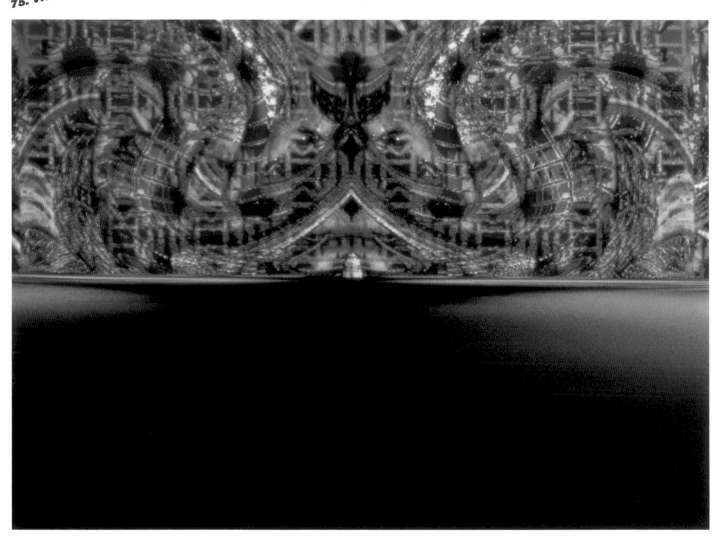

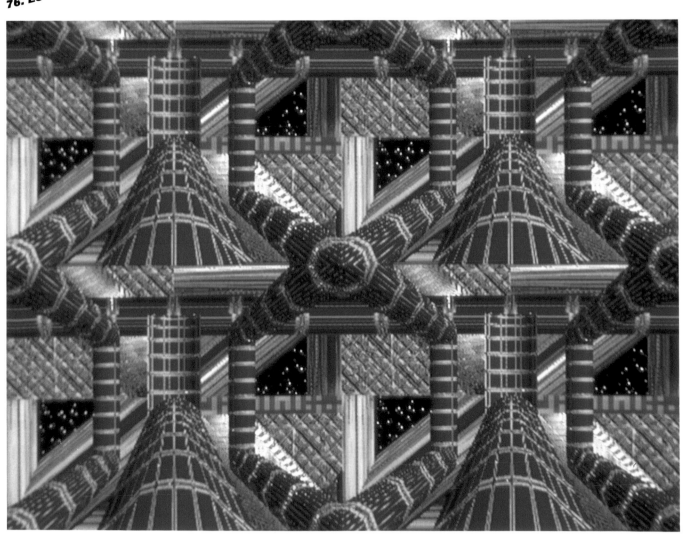

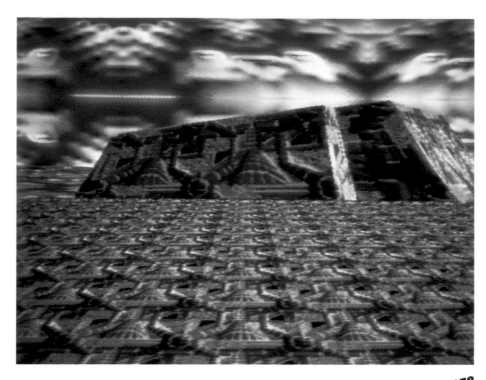

77. DREAM. 1979

78. VOLANDO. 1979

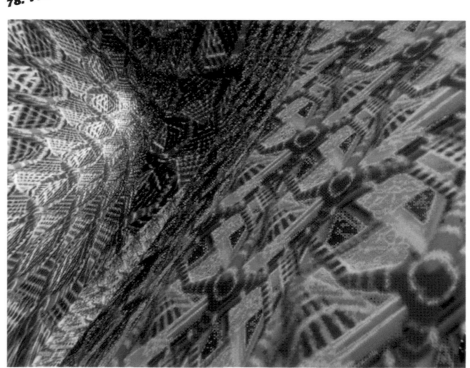

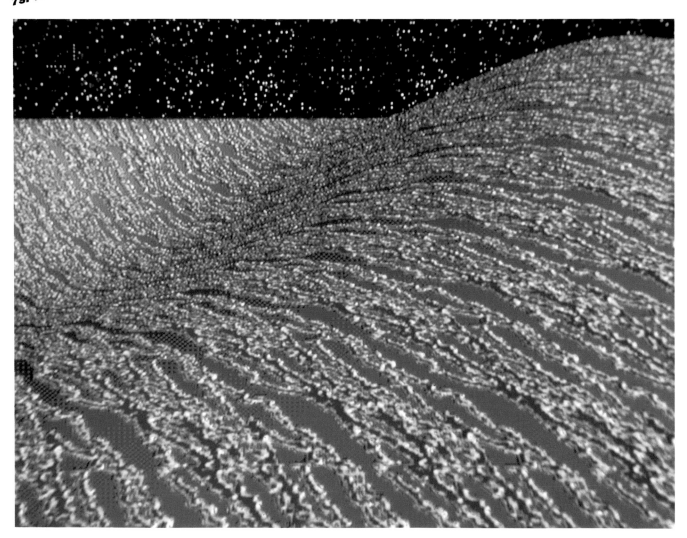

80. ELLEN. 1986

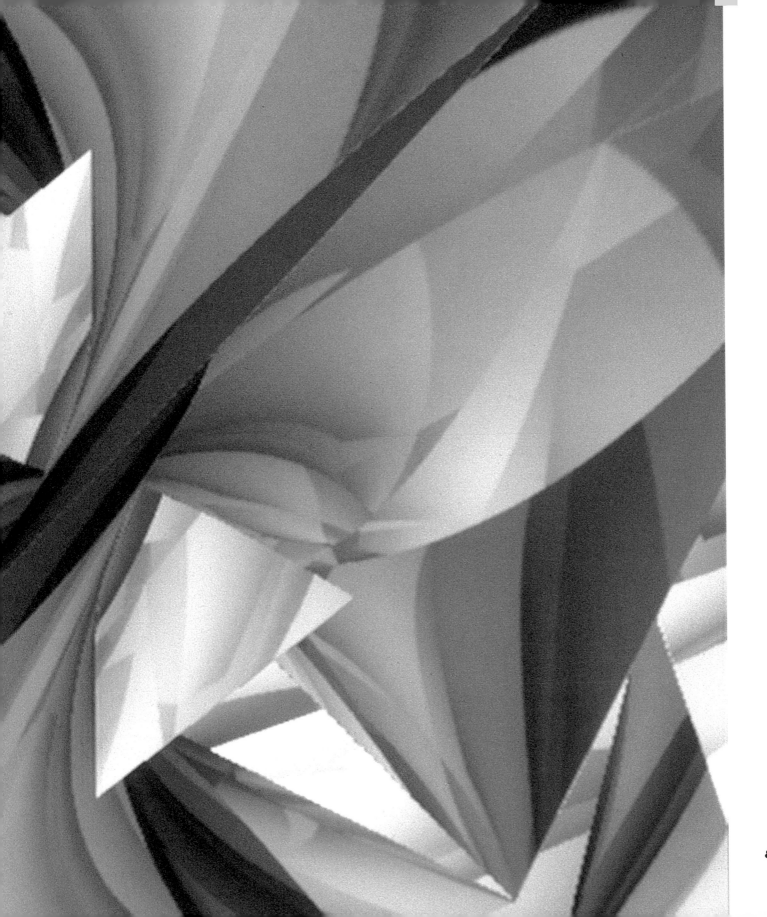

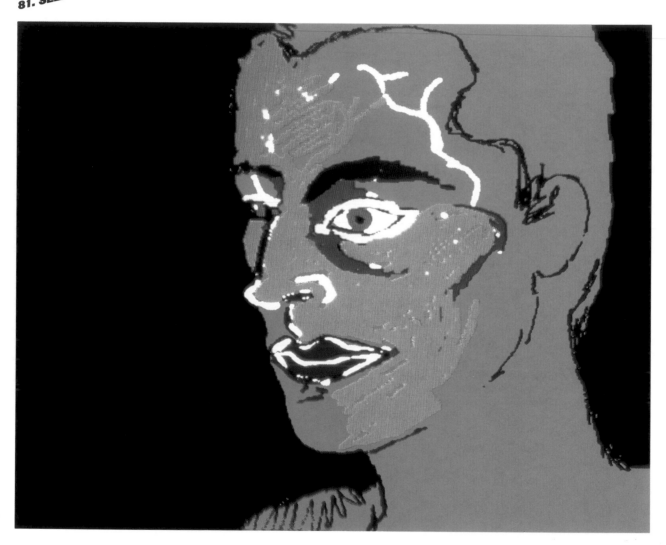

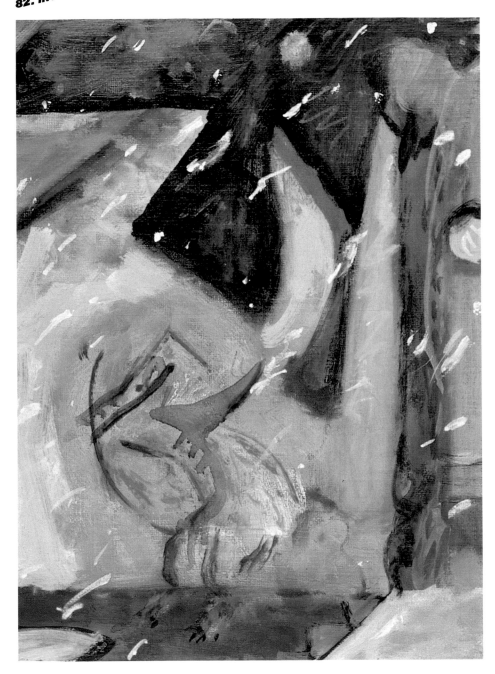

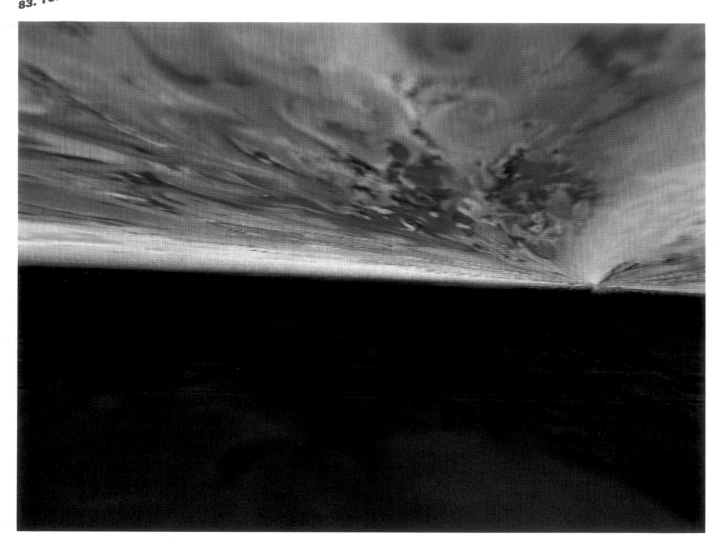

84. SALVADOR. 1982. Oil on board, 31×31"

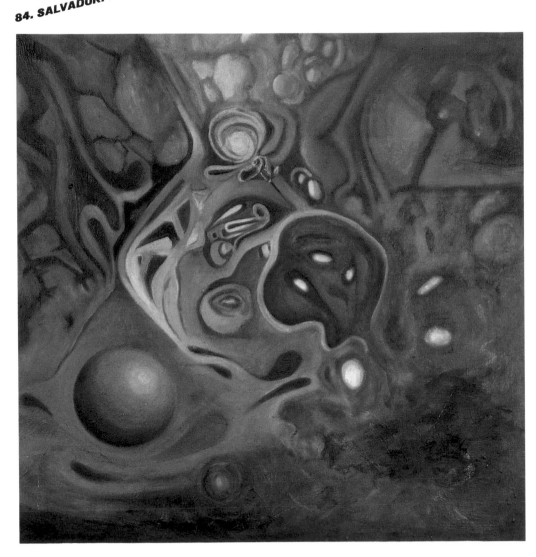

85. PILLARS. 1986

86. ART 3. 1987

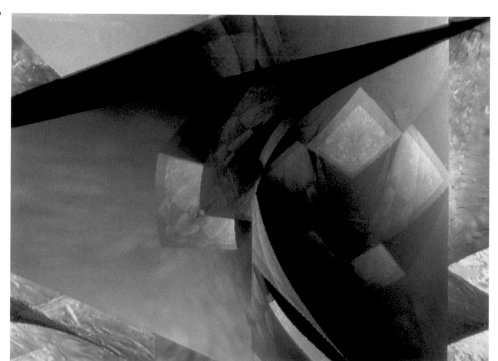

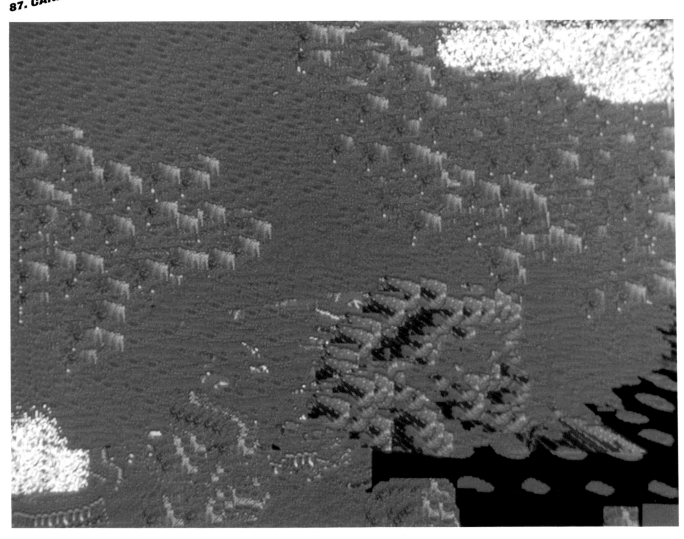

88. DAGGER. 1987

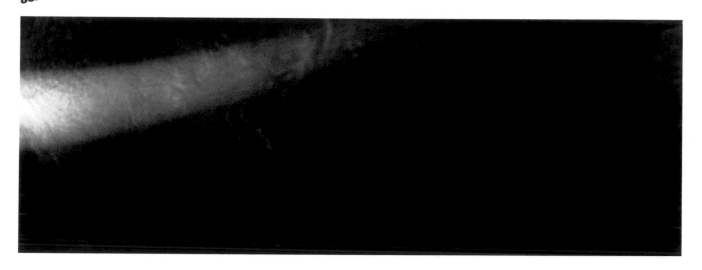

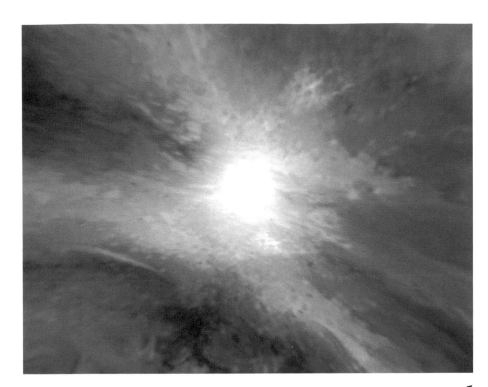

89. NUBES. 1985

90. SUNRISE. 1985

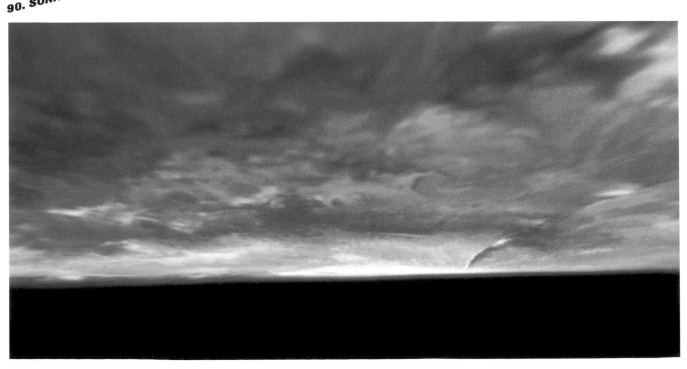

91. THE FIVE OF US. 1983

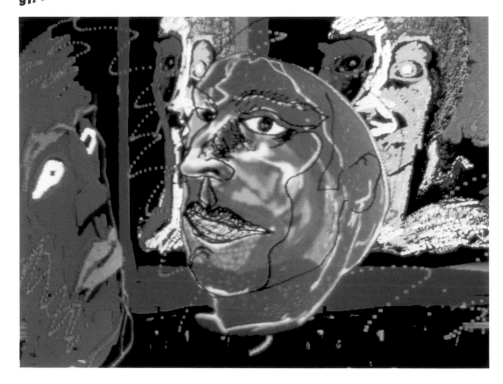

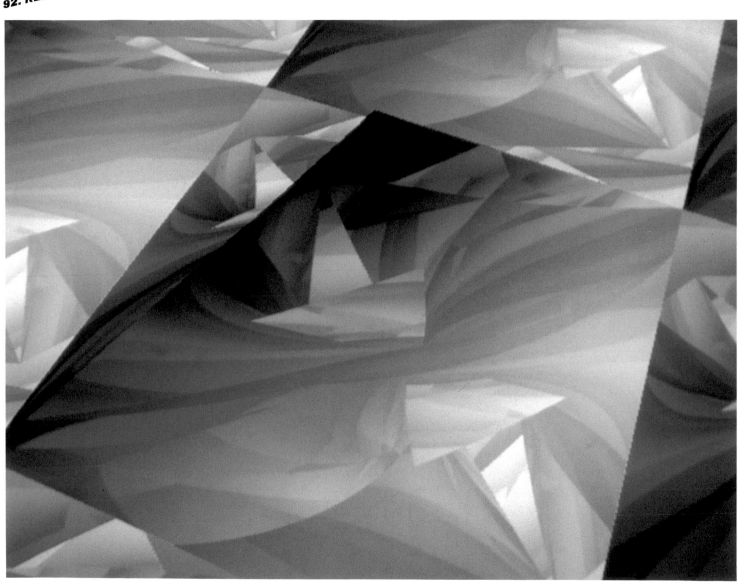

93. SPARK. 1986

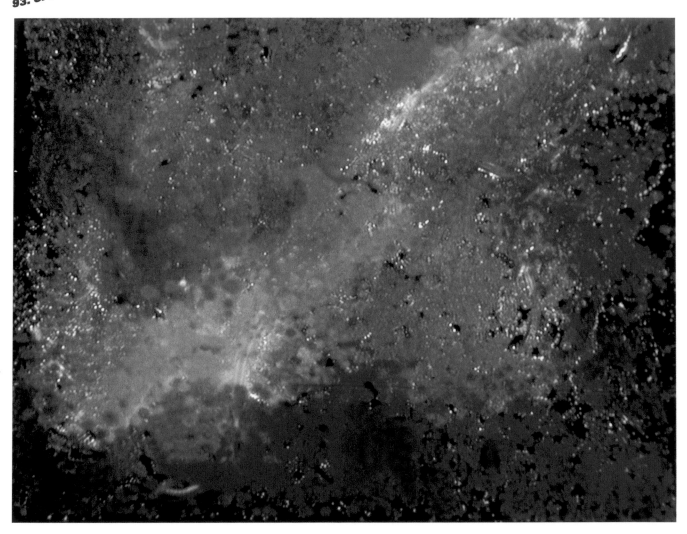

94. MICHELE. 1986

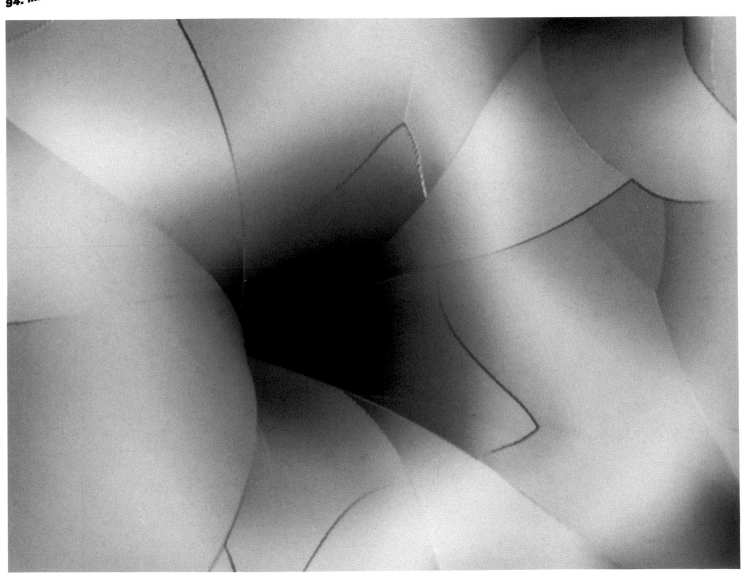

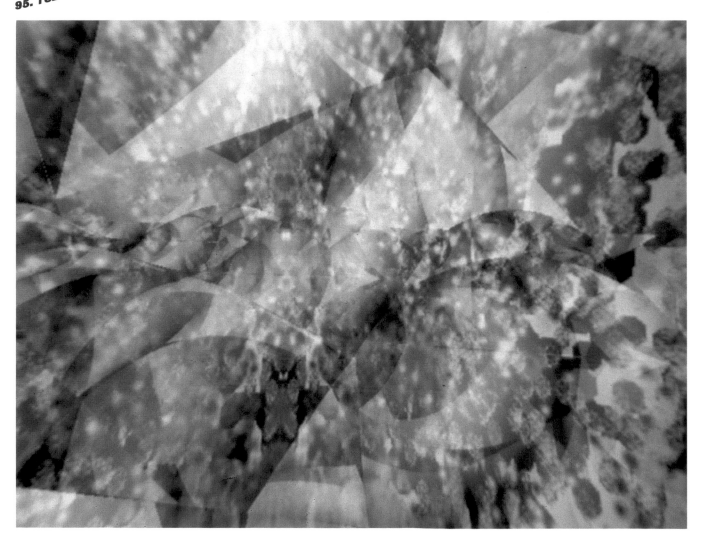

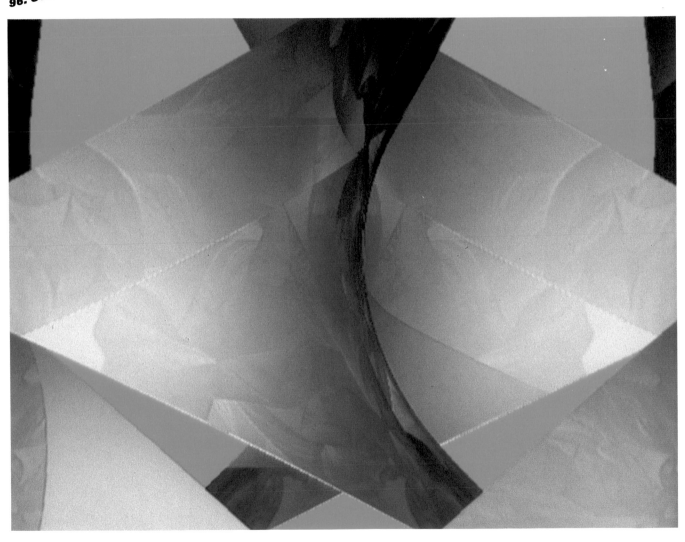

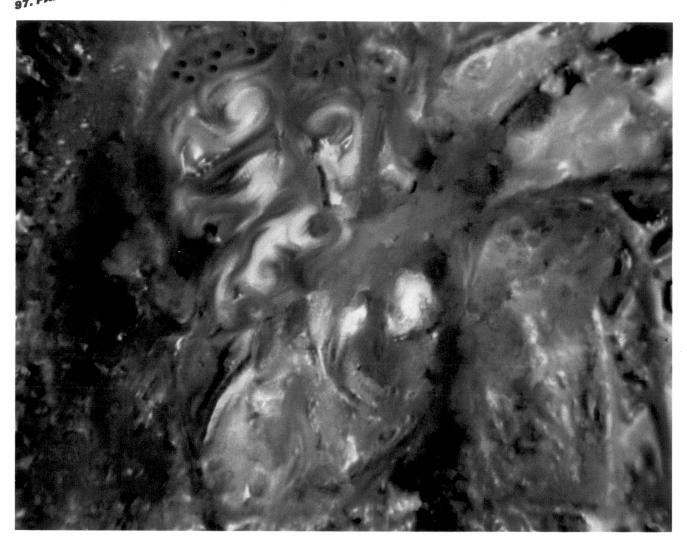

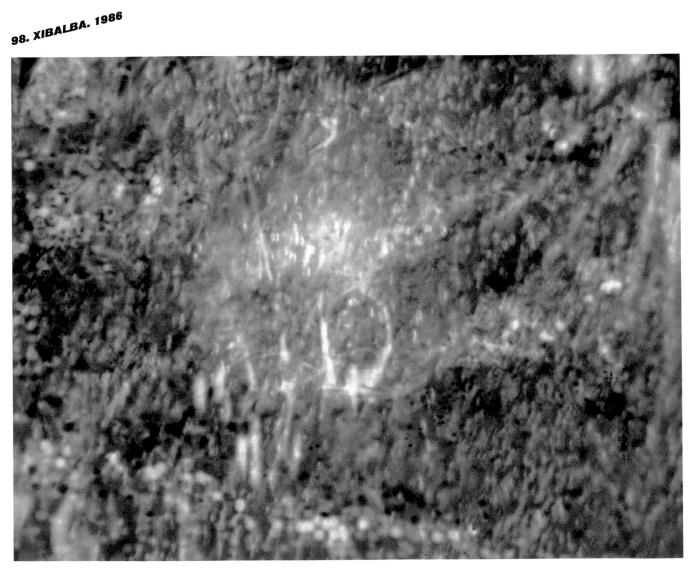

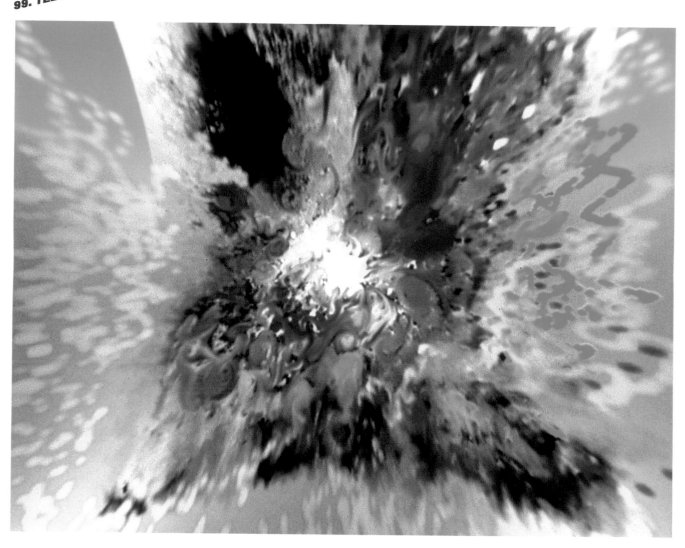

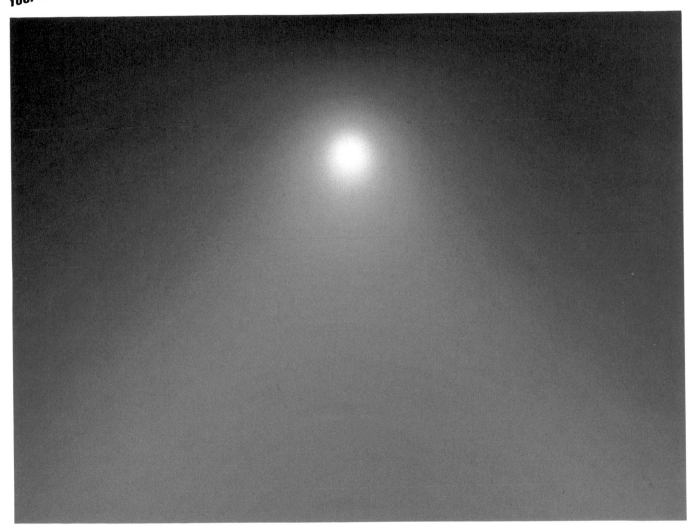

TECHNICAL NOTE

by David Em

Most of the computers I have worked with have existed within the framework of a computing facility. Computing facilities can take a little getting used to. They tend to be in a state of constant flux: old hardware goes out one door, new hardware comes in another. All sorts of machines are plugged together to make all sorts of hybrid systems. These ongoing changes lead to an infinite amount of nightmarish problems: radio frequencies interfere, tape drives malfunction, random noise appears, access codes don't work. But when everything is humming, there's nothing finer than working alone late into the night making pictures in front of a glowing color screen.

Between 1978 and 1984, the heart of the system I worked with consisted of a Digital Equipment Corporation (DEC) PDP 11/55 minicomputer with an Evans and Sutherland 8-bit frame buffer and Picture System 2 (an interactive vector display system) hooked up to it and Conrac RGB monitors. This system allowed me to select from a palette of over 16 million colors, although I could display only 256 of them on the screen at any one time. After 1984, I worked with an upgraded system that used a DEC VAX 780 in place of the 11/55 and a Gould/DiAnza 24-bit frame buffer. With this more powerful configuration, I was able to access and use all 16 million colors at will. Early on I documented the pictures I made by photographing the display screen with a 35mm Nikon camera. Later, I used a Dunn Instruments digital film recorder, which could be controlled directly by the computer.

The computer programs I worked with to make the pictures in this book were written for the most part by Jim Blinn at the time when his software was pioneering the creation of images with computers. His programs, which amounted to a highly specialized electronic-imaging toolkit, were produced over a period of many years on machines whose cost totals in the hundreds of thousands of dollars. As I write this, similar computers and programs are being sold commercially at a small fraction of the original cost, making high-level imaging technology available to individual artists in their studios for the first time. Much of my equipment, therefore, is already completely obsolete. Besides, an equipment list tells nothing at all about what is really involved in making pictures with computers.

My own approach to the medium has always been intuitive. I rarely plan anything in advance, and more often than not I am somewhat surprised at where I wind up. I consider the computer to be an instrument with a keyboard. As an instrument it is no harder or easier to play than a piano. But having created an image on a computer screen, what becomes of it? In some cases, the image on the screen, a study in electronic light, is itself an end product: conceived, executed, and best displayed on the computer. Other times, the capabilities of the computer have served to help me visualize a concept, and the image thus generated has gone on to become the basis for a print or a painting.

Stages in the Development of a Computer Image:
Jim Blinn's Chalices

The following examples show a progression of basic computer graphics rendering techniques, outlining the construction of an image through programming.

Fig. 14. Data points are entered into the computer to define an object, in this case a chalice designed by computer scientist Jim Blinn. A vector-generating program then connects the points with lines. Once the data is input for the X, Y, and Z coordinates of the chalice, basic transformations can be manipulated interactively. Specifically, the chalice can be rotated or viewed from any angle, and its size can be increased or decreased.

Fig. 15. Once the basic coordinates are input, a hidden-line elimination program can be employed to simulate human vision by removing the lines on the back surface of the chalice. Such lines could not be seen by the unaided eye, but they are necessary for the computer to construct the object in three dimensions.

Fig. 16. After the removal of the hidden lines, a surface-shading program is invoked so that the facets of the chalice can be rendered as flat surfaces. The chalice's planes can now be colored to display highlights and shadows (or even translucency). The colors can be changed at will.

Fig. 17. Alternatively, a smooth-shading program can round off the facets of the chalice and convert its hard edges into a smoothly unified surface (using curvilinear interpolations).

Fig. 18. A bump-mapping program is used to texture the smooth surfaces of the chalice. A grid of forms is constructed in low or high relief to create the texture and is then wrapped onto the object (almost any texture can be created).

Figs. 14—18 are reproduced courtesy of James F. Blinn and the Computer Graphics Lab, Jet Propulsion Laboratory

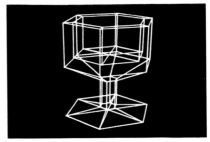

Fig. 14

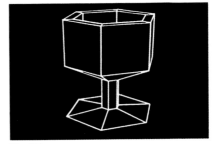

Fig. 15

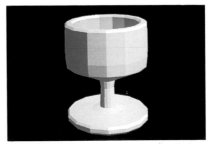

Fig. 16

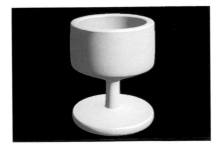

Fig. 17

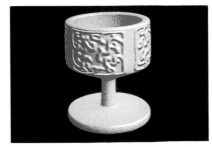

Fig. 18

BIBLIOGRAPHY

Selected Books

Donald Greenberg, Aaron Marcus, Allan Schmidt, and Vernon Gorter; Project Editor William Saunders. *The Computer Image.* Menlo Park, California, and Reading, Massachusetts: Addison-Wesley Publishing Co., 1982.

WGBH Educational Foundation. "Artists in the Lab." In *Nova: Adventures in Science.* Menlo Park, California, and Reading, Massachusetts: Addison-Wesley Publishing Co., 1982.

Melvin Prueitt. "Computer Graphics: A Lens for the Mind's Eye." In *Encyclopedia Britannica 1983 Yearbook of the Future.*

Joseph Deken. *Computer Images: State of the Art.* New York: Stewart, Tabori and Chang, 1983.

Dale Peterson. *Genesis II: Creation and Recreation with Computers.* Reston, Virginia: Prentice Hall Publishing Co., 1983.

Yoichiro Kawaguchi. *Computer Graphics '83.* Tokyo: Senden Kaigi, Inc., 1983.

Michael Arth. *Introspective.* Austin: Linnaea Graphics, 1983.

Melvin Prueitt. *Art and the Computer.* New York: McGraw Hill, 1984.

Joan Scott, ed. *Computergraphia: New Visions of Form, Fantasy and Fiction.* Houston: Gulf State Publishing, 1984.

Donald Michie and Rory Johnston. *The Creative Computer.* London: Penguin Books, 1984.

Dale Peterson. "Painting by Computer." In *The New Book of Popular Science.* Greenwich, Connecticut: Grolier Press, 1985.

Herbert Franke. *Computer Graphics—Computer Art.* 2d ed. New York: Springer Verlag, 1985.

Herbert Franke, Cohei Sugiura, Itsuo Sakane, and Koichi Omura. *Independent Computer Art.* Tokyo: Bijutsu Shuppan-Sha Co., 1986.

William Fleming. *Arts and Ideas.* 7th ed. New York: Holt, Rinehart and Winston, 1986.

Cynthia Goodman. *Digital Visions: Computers and Art.* New York: Harry N. Abrams, 1987.

Selected Periodicals

Marsha Zapson. "Young, Fast and Scientific: Computer Graphics at the Intersection of Science and Art." *Polaroid Closeup* 11 (October 1980):14—17.

Rory Johnston. "Computer Is Leading the Artist into New Trains of Thought." *Computer Weekly,* 26 February 1981: 7.

John Lewell. "The Computer Paintings of David Em." *Business Screen,* October 1981: 38—40.

Peter Sorensen. "Computer Images: An Apple for the Dreamsmiths." *Cinefex* 6 (October 1981): 16.

"Electronic Technology—The Next 25 Years." *EDN* 26 (October 1981): entire issue.

David Gillis. "David Em's Computer Is His Paintbrush." *Cambridge Chronicle,* 24 December 1981.

Ted Nelson. "Smoothers of the Lost Arc." *Creative Computing* 8 (March 1982): 10—14.

"David Em, artiste sur ordinateur." *Micro Systemes* 22 (March—April 1982): 72—81.

Natalie Canavor. "Shows We've Seen." *Popular Photography* 85 (April 1982): 11.

Andrew Epstein. "Smorgasbord of Visual Music at U.C.L.A. Festival." *Los Angeles Times,* 8 June 1982.

Sharon Begley, John Carey, Robb A. Allan, Janet Huck, and Richard Sandza. "The Creative Computers." *Newsweek,* 5 July 1982: 58—61.

Natalie Canavor. "Digital Dimensions." *Popular Photography* 89 (August 1982): 80—81.

"David Em à Paris." *Micro Systemes* 25 (September—October 1982): 56—61.

Peter Sorensen. "Movies, Computers, and the Future." *American Cinematographer* 64 (January 1983): 69—70.

Dinah Berland. "The Computer as an Artist's Tool." *Los Angeles Times Sunday Calendar,* 16 January 1983.

Suzanne Muchnic. "Interfacing with Computers." *Los Angeles Times Sunday Calendar*, 28 February 1983.

"Futurescope." *Science Digest* 91 (March 1983): 75–78.

Kelly Wise. "Camera Never Lies, Does It?" *Boston Globe*, 15 March 1983.

Paul Freiberger. "Museum Displays Computer Art." *Infoworld* 5 (11 April 1983).

Colin Gardner. "The Artist and the Computer at the Long Beach Museum of Art." *Images and Issues* 4 (July–August 1983): 6–8.

"Computer Images." *Amerika*, Fall 1983: 46–47.

"Artist of Light." *Tempo* 28 (Fall 1983): 11–14.

Emmanuel St. Juste. "Interview with David Em." *Promenade*, Fall 1983: 15.

"Computer Graphics." *Al Jamal* 153 (December 1983).

Peter Sorensen. "Simulating Reality with Computer Graphics." *Byte* 9 (March 1984).

Yoko Tanaka. "David Em." *Japan Omni*, April 1984: 82–85.

Barbara Nessim. "Computer Images." *Graphis* 40 (July–August 1984).

Mason Riddle. "A Few Artists Who Take the Computer Seriously." *The Washington Times*, 14 August 1984.

Montxo Algora. *"La Imagen Electronica."* *Cambio* 16 (3 September 1984).

"Gallery." *Byte* 9 (September 1984).

"Traumwelt Aus Bits." *Der Spiegel*, 7 October 1984.

Dale Peterson. "Cybernetic Serendipity." *Popular Computing*, November 1984.

"Billboard Charts the Future." *Billboard*, 15 December 1984.

Owen Davies. "Digital Dreams." *Omni*, February 1985: 78–83.

Kelly Wise. "Computer Art Comes of Age." *Boston Globe*, 16 January 1985.

"Interview de David Em." *La Lettre de l'image*, February 1985.

"L'État de l'art et de l'artiste." *Banc Titre*, March 1985.

Monique Nahas and Marie-Hélène Tramus. "Quand L'Artiste devient informaticien." *La Recherche* 165 (April 1985): 532–535.

Bob Swain. "Sculptures from Memory." *Audio Visual*, April 1985: 54–55.

Simon Morgan. "Placing Art Before the Programmers." *Design*, May 1985.

Montxo Algora. "La Emoción Es lo que Importa." *El Pais Semanal* 436 (18 August 1985).

Patric Prince. "Ten Years of Mastering the 'Brush'." *IEEE Computer Graphics and Applications* 5 (October 1985): 4–7.

Dominic Milano. "Digicon '85, International Arts Conference on Computers and Creativity." *Keyboard*, November 1985: 20.

Frank Dietrich. "Digital Media: Bridges Between Data Particles and Artifacts." *The Visual Computer International Journal of Computer Graphics*, March 1986.

Bernard Perrine. "David Em." *Le Photographe*, April 1987.

EXHIBITION CHRONOLOGY

One-Man Exhibitions

David Em: Art for the 80s. The Colorado Street Gallery, Pasadena, 10 December 1979–15 January 1980.

David Em, Artist. Silverworks Gallery, Los Angeles, 6–27 February 1981.

Digicon. Clarence Kennedy Gallery, Cambridge, Massachusetts, 15 December 1981–10 January 1982; Rencontres Internationales de la Photographie, Arles, July–August 1982 (catalogue); Photokina, Cologne, October 1982; Sforzesco Castle, Milan, January 1984 (catalogue); Chateau D'Eau, Toulouse, March 1985; Spanish Museum of Contemporary Art, Madrid, October 1986 (catalogue); Discovery Center Museum, Fort Lauderdale, March–April 1987.

The Artist in the Lab. Carpenter Center for the Visual Arts, Harvard University, Cambridge, Massachusetts, 23 April–16 May 1983.

David Em. Orange County Center for Contemporary Art, Santa Ana, California, 5 March–9 April 1984 (catalogue with essay by Ray Bradbury).

La Racine Carre de l'oeil: David Em. Palais de Congrès, Monte Carlo, 2–7 February 1987; L'Espace Française, Cité du Futur, Montréal, June–September 1987.

Selected Group Shows

Waves in Space/New Art and Technology. Downey Museum of Art, 27 February–2 April 1981.

High Technology Arts Exhibition. New Library of Congress, Spring 1981; Dallas City Hall, 3 August–28 August 1981 (in association with 1981 ACM SIGGRAPH Conference); Ontario College of Art, Toronto, 3–30 November 1981.

Static: New Images with the Computer. Minneapolis Center of Art and Design, 8–31 October 1982.

Computer Graphics as Art and Design. California State University, Dominguez Hills, 6–27 January 1982.

Timed and Spaced. Alchemie Gallery, Boston, 2–23 February 1983.

Electra. Musée D'Art Moderne de la Ville de Paris, 10 December 1983–5 January 1984 (catalogue).

The Computer and the Artist. Long Beach Museum of Art, 16 January–13 March 1984.

Images et Imaginaires d'architecture. Centre Georges Pompidou, Paris, 8 March–28 May 1984 (catalogue).

Photographs from the Computer. Project Arts Center, Cambridge, Massachusetts, 6–23 January 1985.

Electronic Epiphanies. Valparaiso University, 8–28 February 1985.

Sights and Sounds for the Information Age. Honolulu Academy of Arts, 14–24 March 1985.

Emerging Expression: The Artist and the Computer. Bronx Museum of the Arts, New York, 12 April–22 September 1985.

International High Technology Art. Seibu Museum of Art, Tokyo, 5 October–7 November 1985 (catalogue).

A Retrospective. 1986 ACM SIGGRAPH Art Show, Dallas, 18–22 August 1986. (catalogue).

The Artist and the Computer. Louisville Art Gallery, 1986 (catalogue). Exhibition traveled to twelve venues in the South.

State of the Arts. Galleria dell'Imagine, Rimini, 15 June–6 October 1986.

89th Annual Fellowship Show. Noyes Museum, Oceanhill, California, 28 September–14 December 1986.

Modern Color Photography 1936–1986. Photokina, Cologne, 15–23 October 1986 (catalogue).

Digital Visions: Computers and Art. Everson Museum of Art, Syracuse, 18 September–8 November 1987 (catalogue).

Emerging Expression: Biennial. Bronx Museum of the Arts, New York, 17 September 1987–14 February 1988.

ACKNOWLEDGMENTS

The one hundred images in this book represent my work from 1978 to 1987. I shared that time with many people. When I was getting my feet wet in the computer field, Bob Holzman, Dave Rose, and Mike Plesset, all of the California Institute of Technology's Jet Propulsion Laboratory, went far out of their way to help me feel comfortable in the high-tech world.

I have also had a lot of fun over the years working with computer scientist Jim Blinn and making pictures with his marvelous programs. It has been terribly difficult, however, to record the pictures made on the computer. Had it not been for the efforts and expertise of James Seligman, who was my manager for many years, photographer Albert Dugas, computer technician Sylvie Rueff, and master printer Michael Wilder many of my images would have been seen only on the screen and never been documented.

Michele Small was the one who cared enough to agitate for a book, and it was through her efforts that this project got rolling in the first place. Roberta Spieckerman, my agent, devoted countless hours to the book over a period of three years, and during that time her energetic efforts kept the spirit of the project alive and fresh.

Sam Antupit, with his fine aesthetic sensibility, and David Ross, with his art historical perspective, greatly contributed to the book's form and content. Charles Miers and Alex Jacobson, my business manager, helped finalize the project to where we could all shake on it.

—D.E.